Magic Lantern Guides

Canon
EOS 30D
DIGITAL

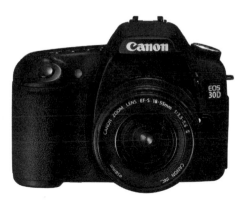

Rob Sheppard

LARK BOOKS

A Division of Sterling Publishing Co., Inc.
New York

Book Design and Layout: Michael Robertson
Cover Designer: Barbara Zaretsky
Editorial Assistance: Delores Gosnell

Library of Congress Cataloging-in-Publication Data

Sheppard, Rob.
 Canon EOS 30D / Rob Sheppard. -- 1st ed.
 p. cm. -- (Magic lantern guides)
 Includes index.
 ISBN 1-57990-971-X (pbk.)
 1. Canon camera--Handbooks, manuals, etc. 2. Digital cameras--Handbooks,
manuals, etc. I. Title. II. Series.
TR263.C3S5223 2006
771.3'3--dc22

 2006015419

10 9 8 7 6 5 4 3 2 1

First Edition

Published by Lark Books, A Division of Sterling Publishing Co., Inc.
387 Park Avenue South, New York, N.Y. 10016

Distributed in Canada by Sterling Publishing,
c/o Canadian Manda Group, 165 Dufferin Street
Toronto, Ontario, Canada M6K 3H6

Distributed in the United Kingdom by GMC Distribution Services,
Castle Place, 166 High Street, Lewes, East Sussex, England BN7 1XU

Distributed in Australia by Capricorn Link (Australia) Pty Ltd.,
P.O. Box 704, Windsor, NSW 2756 Australia

If you have questions or comments about this book, please contact:
Lark Books
67 Broadway
Asheville, NC 28801
(828) 253-0467

Manufactured in China

ISBN 13: 978-1-57990-971-0
ISBN 10: 1-57990-971-X

For information about custom editions, special sales, premium and corporate purchases, please con-
tact Sterling Special Sales Department at 800-805-5489 or specialsales@sterlingpub.com.

Contents

An Upgrade for the Serious Photographer

This guide will help you better use the Canon EOS 30D, though if you upgraded to this camera from a 20D, you may notice that this book is much like the EOS 20D book in this series. This is because the EOS 30D is based on the EOS 20D, with many similarities between the two cameras. There are, however, very distinct differences.

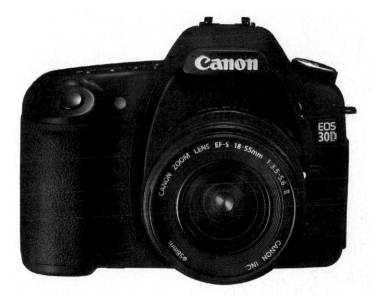

Canon EOS 30D

☞ *Canon has designed a powerful tool for the avid digital photographer with the EOS 30D. For the seasoned professional or the amateur, this camera delivers high performance, winning technology, and a reasonable price tag.*

The Canon EOS 30D is a significant upgrade to the EOS 20D. It builds on the standard the EOS 20D set for affordable, high-quality digital SLRs (D-SLRs). It is a camera designed to meet the requirements of advanced amateurs, yet still be attractive to pros. In some ways this makes the camera a little schizophrenic in that there are elements that few amateurs will use and some features in which pros will have little interest. This book covers them all, however, because all of these features make this a very powerful camera.

The EOS 30D incorporates new technologies introduced by the EOS 5D to give it more advanced capabilities. In many ways, the camera could be seen as the little brother of the 5D rather than a big brother of the 20D. Introduced at PMA in February 2006, this camera is just slightly bigger than the 20D in size, measuring 5.7 x 4.2 x 2.9 inches (145 x 107 x 74 mm) and weighing just 24.7 ounces (700 g). This is enough of a difference that you will notice it as a more solid feeling camera, yet it is still a small D-SLR.

The EOS 30D retains the best of the highly acclaimed basic functions of the EOS 20D: the same Canon-designed, very high-quality 8.2 MP CMOS sensor; the DIGIC II image processor; 5 frames per second (fps) continuous shooting; a multilayer LPF (low pass filter—this is used in front of the sensor to optimize the light hitting the sensor); high-precision 9-point autofocus (AF); a durable magnesium alloy body; a multi-controller on the back; and Canon EOS system compatibility. Some changes are shared with other EOS models (notably the EOS 5D), such as the 2.5-inch LCD monitor with a wide viewing angle, Picture Style settings, and automatic noise reduction. Additional new features include 3.5% spot metering, a tougher, more durable shutter, increased burst rate, more shots per battery charge, a low-speed drive mode, and faster startup. Enhancements unique to the EOS 30D include a Print/Share button, extended Pict-Bridge functions, and improvements in Canon-to-Canon device linkage.

A sophisticated digital SLR (D-SLR) makes capturing even the quietest moments a pleasure.

Many photographers purchased the 30D as an upgrade from an EOS 20D or EOS Digital Rebel. For many others, however, this is his or her first high-quality digital camera. Since, a number of readers are new to D-SLR photography, this book will explain an assortment of topics that are basic to experienced digital photographers (and to anyone reading guides to other Canon EOS D-SLRs). If you are familiar with these terms and concepts, skip ahead to the detailed sections on camera operation. As a matter of convenience (and easier reading), we will usually refer to the Canon EOS 30D simply as the 30D.

You will get the most from the 30D's many capabilities if you understand the key features that distinguish this camera. You don't necessarily need to know how to operate every one of its functions. Once you understand a feature, you

may decide it is not necessary to master it in order to achieve your desired photographic results. Explore those that work for you and forget the rest. You can always delve further into this book later on and work to develop your 30D techniques and skills.

Digital cameras do some things differently than traditional film cameras that make them exciting and fun to use, no matter whether you are an amateur or a pro. For digital beginners, many of these differences may seem complicated or confusing. Though most of the features found on traditional Canon EOS film cameras are also available on the 30D, there are many new controls and operations unique to digital. A number have been added to increase the camera's versatility for different shooting styles and requirements. The goal of this manual is to help you understand how the camera operates so that you can choose the techniques that work best for you and your style of photography.

Differences Between Digital and Film Photography

Not long ago it was easy to tell the difference between photos taken with a digital camera and those shot with a traditional film camera; pictures from digital cameras didn't measure up in quality. Though you may still hear that from photographers still shooting film, the idea that film is better than digital simply is no longer true. With the 30D, you can make 16 x 20-inch prints (40.6 x 50.8 cm) that will match an enlargement from 35mm film.

While there are differences between film and digital image capture, there are many similarities as well. A camera is basically a box that holds a lens that focuses the image. In traditional photography, the image is recorded on film and later developed with chemicals. In digital photography, however, the camera converts the light to an electronic image and can do more to the captured image in terms of internal processing.

Film vs. the Sensor

Both film and digital cameras expose pictures using virtually identical methods. The light metering systems are based on the same technologies. The sensitivity standards for both film and sensors are similar, and the shutter and aperture mechanisms are the same. These similarities exist because both film and digital cameras share the same function: to deliver the amount of light required by the sensitized medium (film or sensor) to create a picture you will like.

However, digital sensors react differently to light than film does. From dark areas (such as navy blue blazers, asphalt, and shadows) to midtones (blue sky and grass) to bright areas (such as white houses and sandy beaches), a digital sensor responds to the full range of light equally, or linearly. Film, however, responds linearly only to midtones (those blue skies and green fairways). Therefore, film blends tones very well in highlight areas, whereas digital sensors often cut out at the brightest tones. Digital typically responds to highlights like slide film and to shadows like print film.

The LCD Monitor

One of the major limitations of film is that you really don't know if your picture is a success until the film is developed. You have to wait to find out if the exposure was correct or if something happened to spoil the results (such as the blurring of a moving subject or stray reflections from flash). Sure, you could shoot a Polaroid, but this requires added gear and additional packages of film. The shot you get with the Polaroid image is not the same as the final shot on film.

With D-SLR cameras you can review your image on an LCD monitor—a screen usually found on the back of the camera—within seconds of taking the shot. While LCDs will not reveal all the minute details, they provide a general idea of what has been recorded, so you can evaluate your pictures as soon as you have shot them.

Film vs. Memory Cards

Memory cards are necessary to store images captured by a digital camera. These removable cards affect photographic technique by offering several advantages over film, including:

- **More photos** – Standard 35mm film comes in two sizes: 24 and 36 exposures. Memory cards come in a range of capacities, and today's commonly available cards are capable of holding many more exposures than film.

- **Removable photos** – Once you make an exposure with film, you have to develop and store the negative and print. Due to a chemical reaction, the emulsion layer is permanently changed and thus, the film cannot be reused. With a memory card, you can erase photos at any time, removing the ones you don't want while opening space for additional photos, simplifying the process of dealing with and organizing your final set of images. Once images are transferred to your computer (or other storage medium such as an accessory hard drive or burning a high-quality DVD-R or CD-R), the card can be reused.

- **Durability** – Memory cards are much more durable than film. They can be removed from the camera at any time (as long as the camera is turned off) without the risk of ruined pictures. CompactFlash cards (like those used in the 30D) are encased in solid plastic so they are unaffected if they are dropped or get wet. They can even be taken through the carry-on inspection machines at the airport without suffering damage.

- **No ISO limitations** – Digital cameras can be set to record at different light sensitivities or ISO equivalents. This can be done at any time, and the card in the camera is able to capture images using many different ISO settings. You can even change the ISO from picture to picture.

- **Small size** – In the space taken up by just a couple of rolls of film, you can store or carry multiple memory cards that will hold hundreds of images.

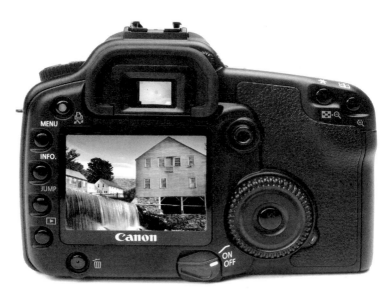

Along with many advanced features, the EOS 30D offers a 2.5-inch LCD Monitor that makes it easier to review and reshoot an image.

- **Greater image permanence** – The latent image on exposed but undeveloped film is susceptible to degradation due to atmospheric conditions such as heat and humidity. With new security precautions for all possessions at airports, the potential for film damage has increased. Traveling photographers find that digital photography allows them much more peace of mind. Not only are memory cards more durable, but their images can also be easily downloaded to storage devices or laptops at any time.

The Histogram

One thing that remains true, whether you are shooting film or digital, is that the wrong exposure will cause problems. Digital cameras do not offer any magic that lets you beat the laws of physics: too little light underexposes an image and too much overexposes an image. LCD monitors give an essentially instantaneous look at your exposure and, while this tiny version of your image isn't perfect, it will give you a good idea of whether you are exposing properly or not.

With traditional film, many photographers regularly bracket exposures (shoot the same image several times while changing settings, e.g. increasing or decreasing shutter speed on consecutive shots) in order to ensure they get the exposure they want. You can still bracket with digital if you want, but there is less of a need because you can check your exposure as you shoot. The EOS 30D's histogram function will help in this evaluation. This feature, which is unique to digital photography, displays a graph that allows you to immediately determine the range of brightness levels within the image you have captured. In addition, the 30D offers a new option compared to the 20D: you get a choice between the standard brightness histogram and the RGB histogram that EOS-1D series cameras offer (most photographers will find the standard, single display perfectly fine—the RGB displays (three graph display) can help pros with color balance issues).

ISO

ISO is an international standard method for quantifying film's sensitivity to light. Once an ISO number is assigned to a film, you can count on it having a standard sensitivity, or speed, regardless of the manufacturer. Low numbers, such as 50 or 100, represent a relatively low sensitivity, and films with these speeds are called slow films. Films with high numbers, such as 400 or above, are more sensitive and referred to as fast. ISO numbers are mathematically proportional to the sensitivity to light. As you double or halve the ISO number, you double or halve the film's sensitivity to light (i.e. 800 speed film is twice as sensitive to light as 400 speed and is half as sensitive to light as 1600 speed).

The histogram gives the photographer a guide to getting a more complete exposure, especially in situations of bright light and dark shadows.

Technically, digital cameras do not have a true ISO. While the sensor has a specific sensitivity to light, its associated circuits change its relative 'sensitivity' by boosting the signal from the chip. For practical purposes, however, a digital camera's ISO equivalent settings correspond to film, so that if you set a digital camera to ISO 400, you can expect a response to light that is similar to an ISO 400 film.

Changing ISO picture-by-picture is easy with a digital camera, but generally not possible with film unless you are willing to constantly reload rolls of varying film speeds into the camera. With a digital camera, you change the 'sensitivity' of the sensor using its electronics when you change the ISO setting. It's like changing film at the touch of a button. This capability provides many advantages. For example, you could be indoors using an ISO setting of 800 so you don't

need flash, and then follow your subject outside into the blazing sun and change to ISO 100. The 30D camera offers an extremely wide range of ISO settings from 100 to 3200 (though its standard, or default range, is 100-1600).

Noise and Grain
Noise in digital photography is the equivalent of grain in film photography. It appears as an irregular, sand-like texture that, if large, can be unsightly and, if small, is essentially invisible. (As with grain, this fine-patterned look is sometimes desirable for certain creative effects.) In film, grain occurs due to the chemical structure of the light sensitive materials. In digital cameras, noise occurs for several reasons: sensor noise (due to several factors, including heat from the electronics and optics), digital artifacts (when digital technology cannot deal with fine tonalities such as sky gradations), and JPEG artifacts (caused by image compression). Of all of these, sensor noise is the most common.

In both film and digital photography, grain or noise will emerge when using high ISO speeds. On any camera, noise will be more obvious with underexposure and may also be increased with long digital exposures in low-light conditions. However, Canon has built advanced noise reduction technology into the 30D. This technology gives the camera incredible image quality at high ISOs with low noise that simply wasn't possible in the past. This camera also has a number of new technologies that create better images with long exposures.

File Formats
A digital camera processes the continuous (or analog) image information from the sensor by converting it to digital data. It converts this data into one of several different digital file formats, including RAW and JPEG.

One very useful feature of D-SLRs is their ability to capture a RAW file. RAW files are image files that include information about how the image was shot but have little processing applied by the camera. They also contain 12-bit

color information, which is the maximum amount of data available from the sensor (it is a little confusing that the RAW file format actually uses a 16-bit file format, though the data from the sensor is 12-bit). The 30D is based on the same advanced RAW format developed for the Canon EOS-1D Mark II, the CR2 file, which includes more metadata (data about the image) than before.

JPEG is a standard format for image compression and is the most common file created by digital cameras. Digital cameras use this format because it reduces the size of the file, allowing more pictures to fit on a memory card.

Both RAW and JPEG files can give excellent results. The unprocessed data of a RAW file can be helpful when faced with tough exposure situations, but the small size of the JPEG file is faster and easier to deal with.

Digital Resolution
When we talk about resolution in film, we are simply referring to the detail that the film can see or distinguish. Similarly, when referring to resolution in the context of lenses, we are measuring the lens' ability to separate elements of detail in a subject. Unfortunately, resolution is not as simple a concept when it comes to digital photography.

Resolution in the digital world is expressed in different ways depending on what part of the digital loop you are working in. For example, for digital cameras, resolution indicates the number of individual pixels that are contained on the imaging sensor. This is usually expressed in megapixels. Each pixel captures a portion of the total light falling on the sensor. And it is from these pixels that the image is created. Thus, an 8-megapixel camera has 8-million pixels covering the sensor.

On the other hand, when it comes to ink jet printing, the usual rating of resolution is in dots-per-inch (dpi), which describes how many individual dots of ink exist per inch of paper area, a very different concept. It can be confusing,

however it is important to remember that resolution in a digital image is totally different than a printer's resolution.

Dealing with Resolution: The 30D offers three different resolution settings between 2 and 8.2 megapixels. You don't always have to choose the camera's maximum resolution, but generally it is best to use the highest setting available (i.e., get the most detail possible with your camera). You can always reduce resolution in the computer, but you cannot recreate detail if you never captured the data to begin with. Keep in mind that you paid for the megapixels in your camera! The lower the resolution with which you choose to shoot, the less detail your picture will have. This is particularly noticeable when making enlargements.

The 30D has the potential of making great prints at 16 x 20 inches and more, but only when the image is shot at 8.2 megapixels. The higher the original shooting resolution, the larger the print you can make. Digital camera files generally enlarge very well in programs like Photoshop, especially if you recorded them in RAW format first (because there is more data in that format to work with), but you need the megapixels for the largest sizes.

So why would you want to shoot with lower resolutions? Only if you have specific needs for that small size and you know the photos will never be needed for a large size. For example, if the photos are specifically for email or webpage use, you do not need to shoot with a high resolution in order for the images to look good on screen. Or if you are simply shooting record shots to inventory a house or use with a research project, and the images will only be reviewed on screen, you do not need the maximum resolution.

The EOS 30D's 8.2 MP sensor provides excellent image detail and ⇨
tonality, especially for making large prints.

The Color of Light

Anyone who has shot color film in a variety of lighting conditions can tell horror stories of awful color. Color reproduction is affected by how a film is "balanced" or matched to the color of the light. Our eyes adapt to the differences, but film does not.

In practical terms, if you shoot a daylight-balanced (outdoor) film while indoors under incandescent lights, your image will have an orange cast to it. For accurate color reproduction in this instance, you would need to change the film or use a color correction filter. One of the toughest common lights to balance is fluorescent. The type and age of the bulbs will affect their color and how that color appears on film, usually requiring specific and careful filtration. Though filters are helpful in altering and correcting the color of light, they also darken the viewfinder, increase the exposure, and make it harder to focus and compose the image.

With a digital camera, all of this has changed. Digital cameras act more like our eyes and create images with fewer color problems. This is because color correction is managed by the white balance function, an internal setting built into all digital cameras. Long a part of video, white balance has been a standard practice for videographers ever since portable color cameras became available approximately 30 years ago. It allowed the cameras to use electronic circuits to neutralize whites and other neutral colors without using filters.

A digital camera works the same way. It can automatically check the light and calculate the proper setting for the light's color temperature. It can also be set to specific light conditions, or it can be custom-set for any number of possible conditions. Thanks to this technology, filters are rarely a necessity for color correction, making color casts and light-loss a non-issue.

A digital SLR removes the apprehensiveness of shooting; you can reshoot an image over and over, erasing those that aren't the best and honing your skill on the spot.

Cost of Shooting

While film cameras have traditionally cost less than digital cameras, an interesting phenomenon is taking place that makes a digital camera a better overall value. Large memory cards have become quite affordable. And, once a card is purchased, it can be used again and again. Therefore, cost per image decreases as the use of the card increases. Conversely, the more pictures you take with film, the more rolls you have to buy, the more expensive the photography becomes.

Now with digital cameras there is virtually no cost to shooting a large number of photos. The camera and memory card are already paid for, whether one, ten, or a hundred images are shot. This can be liberating because photographers can now try new ways of shooting, experiment with creative angles never attempted before, and so much more.

Features and Functions

When you compare today's cameras, you just have to say, "Wow!" The features available are amazing. But keep in mind is that camera manufacturers provide these features to meet the needs of a variety of photographers and therefore to have a broader sales appeal. You might not need them all. Few pros ever use all the features on an advanced camera; they only use what is useful to them.

This book will give you an idea of what is possible on the EOS 30D with the many features available, as well as help you best utilize those that are most important. There is no need to feel guilty if you don't use or even remember every option packed into this camera! However, if you want to try any of them, remember that you won't "waste film" with digital cameras. You can try out every feature contained on your 30D and actually see how it functions. This is a quick and sure way of learning to use your camera, and allows you to choose those that are most useful to you.

Just like the EOS 20D and 5D cameras, the Canon EOS 30D offers a high degree of technological sophistication at a moderate price. With a sensor that contains 8.2 megapixels, the 30D shoots up to 5 frames per second (fps) and up to 30 frames at a time. It also offers one of the quickest start-ups of any digital SLR (D-SLR), fast memory card writing speeds, and other controls that match the performance of recent top pro cameras, such as the EOS 5D.

◁ *The EOS 30D has the flexibility of being fully automatic or manual, and gives the photographer the option to change the settings whenever they want, even between each picture.*

Built with a stainless steel chassis, the camera is housed in a magnesium-alloy body. While more expensive to manufacture, this construction creates a lightweight yet strong unit. The mirror box is made of an extremely high-quality plastic. Canon has slightly redesigned the body around the flash head and lens mount (compared to the 20D) to make the camera, as Canon says, "suggest Canon's upper-range models." The camera engineers have also extended the grip below the shutter button to improve overall handling. The body itself is 2mm thicker than the EOS 20D's. To make the use of the back buttons easier, indented areas have been added around the four buttons on the left back of the camera, and the Delete key now has its own unique location (still in the same area, simply moved out of line of the rest of the keys there). The exterior of the camera is finished with a high-grade, black satin paint with a leather finish.

Note: When the terms "left" and "right" are used to describe the locations of camera controls, it is assumed that the camera is being held in shooting position.

As with all Canon EOS cameras, the 30D uses the Canon EF lens mount and accepts all standard Canon EF lenses. It addition, the camera accepts compact EF-S lenses, designed specifically for small-format sensors. These lenses can only be used on cameras designed specifically to accept them (they sit deeper in the camera body and can damage the mirror of a camera for which they are not designed).

The basic internal construction and how major parts are used in the camera are the same as those of the EOS 20D. Still, some of the internal circuitry and mechanical components have been slightly redesigned to further increase reliability. A good example of this is the professional quality shutter, which is now rated to 100,000 cycles.

Canon EOS 30D Front View

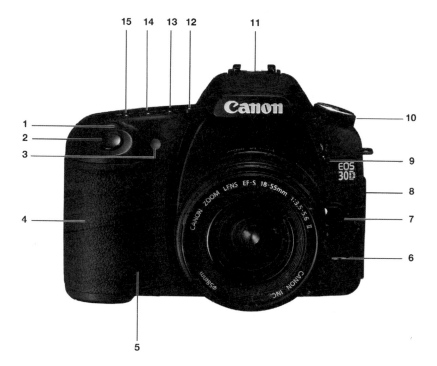

1. Main Dial ⟨⟨⟩⟩ page 32
2. Shutter button page 33
3. Red-eye Reduction/
 Self-timer lamp page 139
4. Grip (battery compartment)
 page 42
5. DC coupler cord hole
 page 42
6. Depth-of-field Preview
 button page 121
7. Lens release button
8. Terminal cover (side)
9. Flash button ⚡ page 135
10. Mode Dial page 114

11. Built-in flash/AF-assist
 beam page 102
12. LCD Panel illumination
 button page 40
13. AF•WB (AF mode
 selection/White Balance
 selection button) page 62
14. DRIVE•ISO (Drive mode
 selection/ISO speed button)
 page 105
15. Metering mode selection/
 Flash exposure compensa
 tion button 回·⚡
 page 108

Canon EOS 30D Rear View

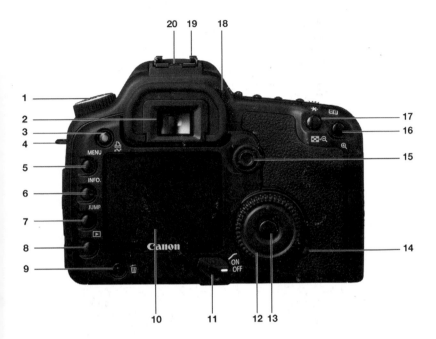

1. Mode Dial page 114
2. Viewfinder Eyepiece page 35
3. Print/Share button ⚏
 page 12
4. Strap Mount
5. Menu button <MENU>
 page 79
6. Info/Trimming orientation
 button <INFO> page 86
7. Jump button <JUMP>
 page 80
8. Playback button ▶ page 85
9. Erase button 🗑 page 89
10. LCD Monitor page 38
11. Power/Quick Control Dial
 switch ⓢ page 33

12. Quick Control Dial ◯
 page 33
13. Set button (SET) page 80
14. Access Lamp
15. Multi-controller ❖
 page 33
16. AF Point selection/Enlarge
 button ✳/❖·⊕ page 87
17. AE lock/FE lock/Index/
 Reduce button ⊞/⊕
 page 123
18. Dioptric Adjustment
 Knob page 37
19. Hot Shoe page 139
20. Flash-sync contacts

Canon EOS 30D Top View

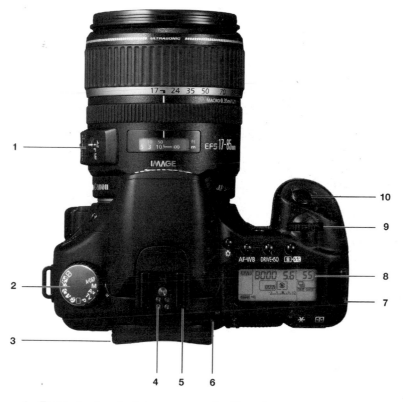

1. Focus mode selector
 (on lens)
2. Mode Dial page 114
3. Eyecup
4. Flash-sync contacts
5. Hot Shoe page 139

6. Dioptric Adjustment
 Knob page 37
7. Strap Mount
8. LCD Panel page 40
9. Main Dial page 32
10. Shutter button page 33

Overview of Features

- Canon-designed 8.2 megapixel CMOS sensor; small-format, APS size
- The technology of the sensor's pixels and micro-lenses enlarges the light sensitive portion of each photosite, offering excellent light-gathering capability and signal-to-noise ratio
- Shoots 5 fps up to 30 frames consecutively (burst rate) at maximum JPEG resolution (11 frames continuous in RAW)
- New, changeable high-speed/low-speed continuous shooting option
- New spot metering, same as EOS-1 Series and EOS 5D
- USB 2.0 interface
- Start-up time of 0.15 seconds
- High-speed shutter up to 1/8000 sec. with standard flash sync up to 1/250 sec.
- 9-point autofocus (AF) system
- Built-in multi-controller for easy access to AF points
- Improved, 2.5-inch LCD monitor, with 170° viewing angle
- New noise reduction options for long exposures
- Fully compatible with entire EOS system of lenses, flash, and other accessories
- FAT32 format permits use of CompactFlash cards larger than 2 GB
- Power-saving design promotes longer battery life

Camera Controls

The EOS 30D uses icons, buttons, and dials common to all Canon cameras. Specific buttons will be explained with the features they control. The 30D often uses two control dials to manage many of the most common and important functions.

Main Dial: Positioned behind the Shutter button on the top right of the camera, this dial allows you to use your "shooting" finger to set things like exposure. The Main Dial works alone when setting shutter speed and aperture. For a number of other adjustments, it works in conjunction with

buttons that are either pressed and released or are held down while the Main Dial is turned.

◯ **Quick Control Dial:** This large, thumb-controlled dial on the back of the camera is used for shooting-related settings and for selecting menu items in the LCD Monitor. It activates for six seconds when an associated operational button is pressed. However, the Power switch to its left controls its functionality. When the switch is in the ON position, the Dial can be used to select the AF point and menu items, or to set white balance, ISO, or flash exposure compensation. With the Power switch set to the angled line (top position), the Quick Control Dial has two additional functions. It can be used to set exposure compensation and to select the aperture in Manual Exposure mode.

❄ **Multi-controller:** The 30D follows the 20D with this control, which sits just above the Quick Control Dial. It is like a mini-joystick controlled by your thumb. It is used for several adjustments that need multi-directional movement, and is especially useful for AF point selection.

Shutter Button: The 30D features a soft-touch electromagnetic shutter release. Partially depressing the Shutter button activates certain camera functions, such as autoexposure and autofocus. This camera is fast enough, however, that there is minimal speed advantage in pushing the button halfway before exposure. It does help, however, when dealing with moving subjects, to start autofocusing early, so the camera and lens have time to find your subject.

Camera Activation

❧ Three-Position Power Switch

The EOS 30D has a three-position Power switch found on the back of the camera below the LCD Monitor. The three positions are: OFF, ON, and a special ON ⌒ that affects the use of the Quick Control Dial ◯ . The icon for the third position is simply an angled line. It almost looks like a

The Power switch, located below the LCD Monitor, turns all camera functions ON or OFF. The angled line setting activates the Quick Control Dial for exposure compensation and aperture selection in M mode.

design element, but it is actually the "On" position for both the camera and the ⊚ for exposure compensation and M mode aperture selection.

Auto Power Off

Auto power off is an important control on most digital cameras but is often not changed by the photographer. You should find this control and consider what you really need from it. The 30D's *Auto power off* selection is in the Set-up Menu ⫏⫏ and can be used to shut power after a duration of idleness spanning from one to 30 minutes. If you do not want the camera to turn itself off, set this feature to *Off* and the camera will remain ON as long as the Three-position Power switch 🖘 is activated.

Auto power off is helpful to minimize battery use, but you may find this frustrating if you try to take a picture and find that the camera has shut itself off. For example, you might be shooting a soccer match and the action stays away from you for a couple of minutes. If Auto power off is set to *1 min.*, the camera will be off as the players move toward you. Now you try to shoot and nothing happens

because the camera is powering back up. You may miss the important shot. In this case, you might want to change the setting to *4 min.* or *8 min.* so that the camera stays on when you need it to.

Access the Auto power off function through the menu operation. Press the MENU button (on back of the camera to left of LCD Monitor) and scroll to the **ƔƮ** using the JUMP button. When **ƔƮ** is highlighted (color code yellow), use the Quick Control Dial ⊙ (the large dial on the back of the camera) to select *Auto power off*, the first option in this Menu. Press SET ⑤ (located in the middle of the ⊙) and you will be given eight different choices ranging from *1 min.* to *30 min.* (including the *Off* option that prevents the camera from turning off automatically). Use the ⊙ and the ⑤ to choose one of these options.

Resetting Controls

With the many controls built into the 30D, it is possible to set so many combinations that at some point you decide to reset it all. You can restore the camera to its original default settings by going to *Clear settings* in the Set-up Menu **ƔƮ** .

The Viewfinder

The 30D uses a standard eye-level, reflex viewfinder with a fixed pentaprism. Images from the lens are reflected to the viewfinder by a quick return, semi-transparent half-mirror (there is no cutoff with Canon lenses EF 600mm f/4 or shorter). The mirror lifts for the exposure, then rapidly returns to keep viewing blackout to a very short period. The mirror is also dampened so that mirror bounce and vibration is essentially eliminated. The viewfinder shows approximately 95% of the actual image-area captured by the sensor. The eyepoint is 20 millimeters, which is good for people with glasses.

The focusing screen is a non-interchangeable, precision matte focusing screen. This screen uses special micro-lenses to make manual focusing easier and increase viewfinder brightness.

The Viewfinder

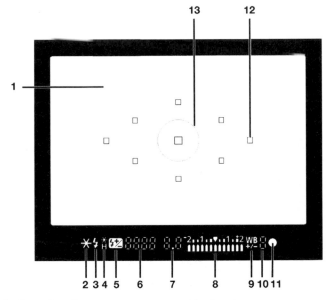

1. Focusing Screen
2. AE Lock/AEB in progress
 ✳
3. Flash ready light/Improper
 FE Lock warning ⚡
4. High-speed sync/
 FE Lock/FEB in progress
5. Flash exposure compensa-
 tion
6. Shutter speed/ISO speed/
 FE Lock (FEL)/ buSY/Built-in
 flash recycle

7. Aperture
8. Exposure level, compensa-
 tion amount/AEB range/
 Red-eye Reduction
 indicator
9. White Balance Correction
10. Maximum burst rate
11. Focus Confirmation light
 ●
12. AF point
13. Spot Metering circle

The viewfinder provides 0.9x magnification and includes new superimposition display optics to make information in the viewfinder easy to see in all conditions. The display includes a great deal of data about camera settings and functions, though not all these numbers are available at once. The camera's nine autofocus (AF) points are on the

focusing screen, and the solid band at the bottom of the screen shows exposure information, flash information, white balance correction, maximum burst, CF card information, and AF/MF (auto/manual) focus confirmation (a circle appears on the far right when the camera is in focus). New to the 30D, ISO is now displayed in the viewfinder when the DRIVE•ISO button is pushed. Depth of field can be previewed through the viewfinder by using the Depth-of-Field Preview button, near the lens on the lower left front of the camera.

The viewfinder's Diopter Adjustment knob is above and to the right of the eyecup.

Viewfinder Adjustment

The 30D's viewfinder features a built-in diopter adjustment (a supplementary lens that allows for sharper viewing). The diopter will help you get a sharp view of the focusing screen so you can be sure you are getting the correct sharpness as you shoot. For this to work properly, you need to adjust the diopter for your eye. The Adjustment knob is just above the eyecup, slightly right. Fine-tune the diopter setting by looking through the viewfinder at the AF points. Then rotate the Dioptric Adjustment knob until the AF points appear sharp. You should not look at the subject that the camera is focused on, but at the actual points on the viewfinder screen. If you prefer, you can also use the information at the bottom of the screen for this purpose.

Some Canon literature claims you can use this adjustment to see through the camera comfortably with or without eyeglasses, though I have found that the correction isn't really strong enough for most people who wear glasses regularly (like me).

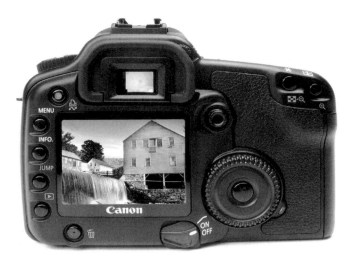

The LCD Monitor lets you review each image, erase unwanted images on the spot, and gives you access to control menus.

The LCD Monitor

The LCD Monitor is probably the one feature of digital cameras that has most changed how we photograph. Recognizing its importance, Canon has really put in a great one in the 30D, the same LCD used in the 5D and 1D Mark IIN cameras. This is a superb 2.5-inch, high-resolution LCD screen in the Monitor found on the back of the camera. With 230,000 pixels, very wide viewing angle, and greatly improved visibility, this screen is extremely useful for evaluating images.

The LCD Monitor in the 30D can also display graphic representation of exposure values, called a histogram (see page 111—the 30D actually can display luminance and RGB histograms). The ability to see the recorded picture combined with an exposure evaluation means that under and overexposures, color challenges, lighting problems, and compositional issues can be dealt with on the spot. Flash photography in particular can be checked, not only for correct exposure, but also for other factors such as the effect of lighting ratios when multiple flash units and/or reflectors are used. No Polaroid film test is needed. Instead, you can see the actual image that has been captured by the sensor.

In addition, the camera will rotate images in the LCD Monitor. Some photographers love this feature, some hate it, but you have the choice. This Auto rotate function makes vertical images smaller, but verticals display properly without holding the camera in the vertical position (and they display vertically when they go into the computer as long as the software recognizes that command in the EXIF file data). On the other hand, turning the Auto rotate feature off keeps the image as big as possible, but it appears sideways in the LCD. In addition, the 30D adds a new twist to this feature by allowing you to automatically rotate images when they are opened in the computer, but not on the LCD. This is an advantage because it allows you to keep the larger image on the LCD, yet have images rotated when they open in the computer.

You can magnify an image during playback up to 10x in the monitor in 15 steps (you can set this), and the enlarged photo is scrollable so you can inspect all of it. The 30D also adds capability to the JUMP function. Before, you could view up to 10 images. Now you can jump 100 images or search by shooting date. This is changed once you get to the Jump screen by pressing SET ⑤ and using the Quick Control Dial ◎ . Also new to the EOS 30D is an image enlarge function for convenient review through the Custom Functions (C.Fn) menu.

The LCD Panel

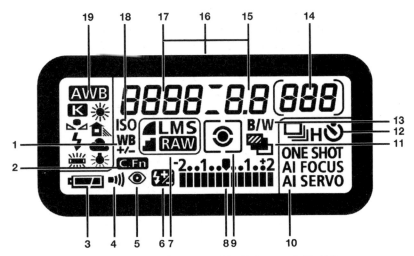

1. White balance correction page 67
2. Custom Function page 91
3. Battery check
4. Beeper
5. Red-eye Reduction page 139
6. Flash Exposure Compensation page 136
7. Image recording quality page 73
8. Exposure level indicators
9. Metering Mode page 108
10. AF mode page 102
11. Autoexposure Bracketing (AEB) page 125

12. Drive mode/Self-timer page 105
13. Black-and-white/Monochrome shooting page 60
14. Shots remaining/Self-timer countdown/Bulb exposure
15. Aperture
16. AF Point selection/CF Card Warnings/Cleaning Sensor page 104, 49, 46
17. Shutter speed/buSY
18. ISO speed page 107
19. White Balance page 61

Not to be confused with the LCD Monitor, the small black and gray panel on the top of the 30D is designed to display shooting information. It sits to the right of the viewfinder and is always operational when the camera is on. It displays information about camera settings, including exposure, white balance, drive settings, metering type, and much more. It can be illuminated in dark conditions by pressing the LCD Panel Illumination button ☼ just above the Panel.

40

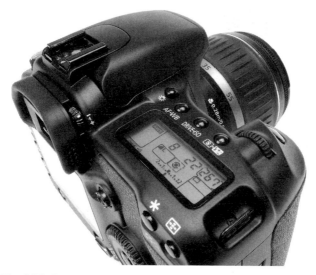

The LCD Panel on the top right of the camera shows current shooting information, such as white balance settings, battery power, shutter speed, aperture, and metering modes.

Power

The EOS 30D is powered by nickel metal hydride (NiMH) rechargeable batteries: BP-511A, BP-514, BP-511, or BP-512 battery packs. The BP-511A that comes with the camera holds the most power. In addition, the 30D now has a new battery display with four icons that designate increments of power remaining, like the EOS-1 series and 5D camera, so you can better judge a battery's remaining charge.

The camera is designed for efficient use of battery power. The new 2.5-inch monitor does consume extra power, so Canon engineers have incorporated a microcomputer power management system. As a result, you can actually get more shots from this camera per battery charge than the 20D. However, power consumption is highly dependent on how long different features, such as flash, AF, and the LCD Monitor, are used. The more the camera is active, the shorter the

battery life, especially with regard to LCD Monitor and built-in flash use. Be sure to have backup batteries (and it is always a good idea to shut the camera off if you are not using it).

Low and high temperatures will reduce the number of shots that can come from your battery. In addition, it is never wise to expose your camera or its accessories to heat or direct sunlight (i.e., don't leave the camera sitting in your car on a hot day or on a cold one). The BP-511A is rated at 8.4 volts and it takes about 100 minutes to fully charge on the CG-580 charger that is included with the camera. It can also be charged in the CB-5L charger used with older cameras, but that charger has a separate cord. The CG-580 is a one-piece compact unit with built-in, foldout power prongs.

Battery Grip BG-E2 attaches to the bottom of the camera and can be used with two BP-511A or equivalent batteries, offering twice the number of shots possible. In addition, the grip has an adapter to allow six AA-size batteries to be used. Many photographers also like this grip because it makes vertical shooting easier as it includes a Vertical-grip Shutter button, AE Lock button, and AF-Point Selection button. The AC Adapter Kit (ACK-E2) is useful to those who need the camera to remain consistently powered up (i.e., for scientific lab work). Another power adapter, the CA-PS400, charges two batteries simultaneously, and with the DR-400 DC coupler cord can be used to supply AC power as well.

It is important to have extra batteries in any shooting situation so that you don't miss a potential shot because you are waiting for batteries to charge. ⟹

Date/Time

Time and date are established by first going into the Set-up Menu ¶¶ . Next turn the Quick Control Dial ⊙ to select *Date/Time*, then press the SET button ⒮ⒺⓉ , located at the center of the ⊙ . Continue to use the ⊙ and the ⒮ⒺⓉ to scroll to the current time and date.

A special lithium battery at the left side of the battery compartment holds the date and time "memory." Canon says you shouldn't need to change this very often (the life is about 10 years). It is easy to do—you simply slide the battery holder out and put in a new battery.

The Sensor

The EOS 30D uses a highly engineered 8.2-megapixel sensor (3504 x 2336 pixels). It can create images that will make superb, film-quality 16 x 24-inch prints (406 x 610 mm) as well as quality magazine reproduction across two pages. I know of National Geographic photographers, for example, who started using the EOS 20D for its high image quality and easy portability. They are now using the 30D for its refined features (especially the 2.5-inch LCD; a huge benefit for the working pro). The sensor is identical in both cameras.

The 30D's APS-sized CMOS sensor is the same size as that used for the 20D and Digital Rebel XT (it is named APS-sized, or APS-C, because it is the size of film used in the old Advanced Photo System – 22.5 mm x 15 mm). Because this sensor covers a smaller area (small-format sensor) than a 35mm film frame, it records a narrower field of view than a 35mm film camera. To help photographers who are used to working with 35mm SLRs visualize the narrower field of view, a magnification factor of 1.6 is applied to the lens' focal length. Thus, on the 30D, a 200mm lens will have a field of view similar to that of a 320mm lens on a 35mm camera. Remember, the focal length doesn't change, just the view seen by the 30D's sensor.

This magnification factor is great for telephoto advocates. However, it causes a problem at the wide-angle end, where a 28mm lens now acts like a 45mm lens on a 35mm camera. A fairly wide lens loses most of its wide-angle capabilities.

Wide angles of view used to be difficult to get with small-format sensors. But the 30D accepts the well-designed Canon EF-S lenses, which are specially engineered for this format. They include a highly rated 10-22mm zoom that offers an equivalent 16-35mm focal length.

Though small-format, the sensor in the 30D demonstrates how good sensor technology is today. It adds nearly a third more pixels, so obviously each pixel has to be smaller. This sensor's 8.2 megapixels offer the same ISO range as the old EOS 10D (6.3-megapixel sensor), yet yield less noise and a higher dynamic range.

Low noise characteristics are extremely important to advanced amateur and professional photographers who want the highest possible image quality. The 30D gives an extraordinarily clean image with exceptional tonalities and the ability to be enlarged with superior results.

Several other things contribute to this improved imaging quality. Canon has worked hard on the design and production of their sensors. They have developed a special on-chip RGB primary filter with larger micro-lenses that reduce the gaps between pixels. This increases the light to each sensor element, resulting in more image signal and less noise. In addition, the camera has a low-noise, high-speed output amplifier as well as power saving circuitry that also reduces noise.

With such low noise, the sensor offers more range and flexibility in sensitivity settings. ISO settings range from 100-1600 in 1/3-stop increments, and an extra choice of 3200 can be accessed in Custom Function menu. While the higher settings do exhibit more noise than the lower settings, even 1600 and

3200 offer remarkable quality considering the speed. Such high settings serve as well as they do because of the intensive work Canon put into the design and production of their sensors.

The on-chip RGB primary color filter uses a standard Bayer pattern over the sensor elements. This is an alternating arrangement of color with 50% green, 25% red, and 25% blue; full color is interpolated from this data. In addition, an infrared cut-off, low-pass filter is located in front of the sensor. This three-layer filter is designed to prevent the false colors and the wavy or rippled look of surfaces (moiré pattern) that can occur when photographing small, patterned areas with high-resolution digital cameras.

Cleaning the Sensor

The EOS 30D does allow you to clean the sensor, but there are precautions to be taken. You must do this carefully and gently, indoors and out of the wind. Your battery must be fully charged so it doesn't fail during cleaning, or you can use the AC adapter. The sensor is very sensitive, so proceed at your own risk. If the gentle cleaning described below doesn't work, you should send the camera to a Canon Service Center for a thorough cleaning.

Note: Though this is described as cleaning the sensor, you actually do not touch the sensor. You are cleaning the protective glass cover over the sensor. Though the cover is not as delicate as the sensor, it is not made for rough handling.

To clean the sensor, turn the camera on and go to the Set-up Menu ⚏ . Scroll down using the Quick Control Dial ◯ until *Sensor clean* is highlighted. Press the SET button ⊛ and you will get a new screen—now just follow the instructions. You'll be given *OK* and *Cancel* options. Select *OK* and the LCD Monitor turns off, the mirror locks up, and the shutter opens. *CLn* will blink on the LCD Panel. Take the lens off. Then, holding the camera face down (not face up as seen in the manual), use a rubber-bulb blower to gently blow any dust or other debris off the bottom of the lens opening first, then off the sensor. Do not use brushes or

compressed air because these can damage the sensor's protective surface. Turn the camera off when done. The mirror and shutter will return to normal. Put the lens back on.

Caution: Never leave a D-SLR without a body cap for any length of time. Lenses should be kept clean and capped when not in use and rear caps should always be used when a lens is not mounted. These practices will help to prevent dust from reaching the sensor. See also, Cleaning the Camera, pages 50-51.

Note: Canon specifically recommends against any cleaning techniques or devices that touch the surface of the imaging sensor.

Mirror Lockup

For really critical work on a tripod, such as shooting long exposures or working with macro and super telephoto lenses, sharpness is improved by eliminating the vibrations caused by mirror movement. This is accomplished by locking up the mirror in advance using the EOS 30D's Mirror Lockup function. However, it does mean the viewfinder will be blacked out and the only available drive mode will be single shot (no matter what you have set).

This feature is set with Custom Function (C.Fn) 12 and will be cancelled automatically after 30 seconds. Once set, you press the Shutter button and the mirror will lock up. Press the Shutter button again to make the exposure. Use a remote switch or the self-timer to keep all movement to a minimum. This is a good use of the self-timer—the shutter will go off two seconds after the mirror is locked up, allowing vibrations to dampen. The self-timer does not work when Bulb Exposure and Mirror Lockup are used together.

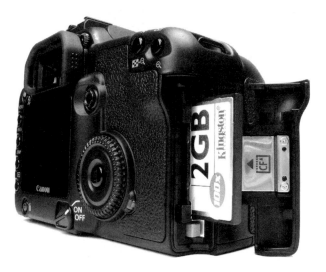

Memory cards come in many sizes, even up to 8GB, which can give you more frames per card, especially when shooting in memory-hungry RAW file type.

Memory Cards

The Canon EOS 30D uses CompactFlash (CF) memory cards. These cards are a standard in the industry and readily available at most stores carrying digital cameras. You will need a sizeable card to handle the image files of this camera. I can't recommend anything less than 512 MB and I would suggest a 1 GB card (or more). Such cards make it easy to shoot both RAW and JPEG (a very good way of getting the best of both).

You will hear people getting worried about memory cards and they will treat them as if they are very fragile. Compact-Flash cards are very sturdy, durable devices. They are not damaged by airport security X-rays, nor are they hurt if you drop them or they fall into the water. One note, however, is that the Microdrive type of memory card is literally a tiny hard drive and will be damaged if you drop it or it falls into water (security X-rays have no effect). Heat will damage any type of card.

To remove the memory card from your camera, simply open the Card Slot Cover on the right side of the camera and push the Card Eject button. It is a good idea to turn the camera off before doing this, even though the 30D will automatically shut itself off when the memory card door is opened. The habit of turning the camera off will let it finish recording to the card. If you should open the Card Slot and remove the card before the camera has written a set of files to it, there is a good possibility you will corrupt the directory or damage the card, making the files impossible to read.

You can choose how the camera deals with numbering the images on the card, and the 30D includes some new options. The numbers can go continuously from 0001 to 9999 even when you change cards, the camera can reset numbers every time you make a change, or you can force a manual reset at any time (these are all accessed with the Set-up Menu ¶† under *File Reset*). There is no arbitrary advantage to either method of numbering, it is a personal preference depending on your workflow needs.

New to the 30D, the camera allows folders with up to 9999 numbers for images (I say numbers because if you erase files, the camera will still continue numbering from where it left off so that you may actually have fewer than 9999 images). Manual reset puts you back to 0001 and in a new folder.

Continuous numbers can make it easy to track image files over a time period. Resetting numbers will let you organize a shoot by using different CF cards. Folders will go up to 999. Once image 9999 is recorded, you will get a message, "FuLL." At that point you have to replace the CF card (formatting it would also work, but then you would lose your images).

Formatting Your Memory Card

Caution: Formatting will erase all images and information stored on the card, including protected images. Be sure that you do not need anything on the card to be saved before you format. (Transfer important images to a computer or other downloading device before formatting the card.)

Before you use a memory card in your camera, it helps to format it specifically for the 30D. To do so, go to the Set-up Menu ▼▼ , then scroll to *Format* using the Quick Control Dial ⊙ . Press the SET button ⊛ and the Format menu will appear on the LCD Monitor. It will tell you how much of the card is presently used with images and how big the card is. Use the ⊙ to move the choice to *OK*, press ⊛ , and formatting will occur. You will see a screen showing the progress of the formatting. Keep in mind that formatting will erase all of the images on the card, whether they were previously protected or not!

Note: Formatting your CF card once in a while is a good idea to clean your memory card and keep its data structure organized. However, you should avoid formatting the card in a computer because it may use a different file structure than a digital cameras; this can make the card unreadable for the camera. If that happens, try formatting the card again in the camera.

Cleaning the Camera

It is important to keep your camera clean in order to minimize the amount of dirt or dust that could reach the sensor. A good kit of cleaning materials should include the following: a soft camel hair brush to clean off the camera, an anti-static brush and micro-fiber cloth for cleaning the lens, a pack towel for drying the camera in damp conditions (available at outdoor stores), and a small rubber bulb to blow off debris from the lens and the camera (you can get these from a camera store, or use an ear-syringe or a baby's enema bulb—they both work very well).

Always blow and brush debris from the camera before rubbing with any cloth. For lens cleaning, blow and brush first, then clean with a micro-fiber cloth. If you find there is residue on the lens that is hard to remove, you can use a lens cleaning fluid (be sure it is made for camera lenses). Never apply the fluid directly to the lens, as it can seep behind the lens elements and get inside the body of the lens. Apply with a cotton swab, or just spray the edge of your micro-fiber cloth. Rub gently to remove the dirt, then buff the lens with a dry part of the cloth. Replace the cloth in its protective packet to keep it clean. You can wash it in the washing machine (and dry it in the dryer) when it gets dirty.

You don't need to be obsessive about cleaning your camera, just remember that a clean camera and lens helps to ensure that you don't have image problems. Dirt and other residue on the camera can get inside when changing lenses, which causes a problem if it ends up on the sensor. Dust on the sensor will show up as small, dark, out-of-focus spots in the photo (most noticeable in light areas, such as sky). You can minimize problems with sensor dust if you turn the camera off when changing lenses (that keeps static charge from building up), as well as by keeping a body cap on the camera and lens caps on lenses when not in use. (See also, Cleaning the Sensor on page 46.)

In-Camera Processing
and File Formats

The RAW format gets a lot of discussion among photographers today. It is a superb format, to be sure, but it is not for everyone. Yet some photo "gurus" would have you feel guilty if you don't use RAW, that somehow you are "less" of a photographer. That is really unfortunate because photographic technology should serve the photographer and not the other way around.

There is a sadly mistaken notion that JPEG is a file format for amateur photographers while RAW is a format for professionals. I say sadly because any false idea like this can hurt photographers. Pros definitely use JPEG and many amateurs use RAW (technically, JPEG is a compression scheme and not a format, but the term is commonly used to denote format and that is how we will use it).

There is no question that RAW offers some distinct benefits for the photographer who needs them, including the ability to make greater changes to the image file before the image degrades from strong processing. The 30D's RAW format (called CR2 and originally developed by Canon for the EOS-1D Mark II) includes revised processing benefits to make it more flexible and versatile for photographers than previous versions (you do need to upgrade your RAW software in order to use it).

◁ *The EOS 30D offers several choices in JPEG and RAW. JPEG is adequate for most purposes, while the RAW file type offers more versatility for advanced image processing.*

However, RAW is not for everyone. It can require more work and time to organize, review, and process than other formats. For the photographer who likes to work quickly and wants to spend less time at the computer, JPEG may offer distinct advantages and, with the 30D, even give better results. This might sound radical considering what some "experts" say about RAW in relation to JPEG, but I suspect they have never shot an image with an EOS camera set for high-quality JPEG capture.

The reason the 30D delivers such exceptional images using JPEG is because of Canon's unique DIGIC Imaging Engine (DIGIC for short). Canon has long had exceptionally strong in-camera processing capabilities, and the version of their high-performance processor in the 30D, called DIGIC II, builds on the technology from previous Canon processors.

DIGIC II intelligently translates the image signal as it comes from the sensor, optimizing that signal as it is converted into digital data. In essence, it is like having your own computer expert making the best possible adjustments as it processes the captured RAW data file for you. It works on the image in-camera after the shutter is clicked and before the image is recorded to the memory card, improving color balance, reducing noise, refining tonalities in the brightest areas, and more. In these ways it has the potential to make JPEG files superior to unprocessed RAW files, reducing the need for RAW processing.

It is amazing that the DIGIC II handles data so fast that it does not impede camera speed. There is a single chip in the 30D with four-channel signal reading and image data processing, just as in the 20D. Color reproduction of highly saturated, bright objects is handled quite well. Auto white balance is excellent, especially at low color temperatures (such as tungsten light). In addition, false colors and noise, which have always challenged digital capture, are reduced with DIGIC processing (and this is something that RAW files cannot offer).

The EOS 30D offers a fast 5 fps in continuous shooting mode is the perfect choice for catching just the right moment, especially with a moving subject.

DIGIC II also affects the 30D's ability to write image data to the memory card in both JPEG and RAW. Write speed is now faster, enabling the camera to take advantage of the benefit offered by high-speed memory cards. It is important to understand that the speed of a memory card does not affect how quickly the camera can take pictures. Rather, it affects how fast it can transfer images from its buffer to the card. It won't change the shots per second, but it will affect how many images can be taken in succession.

Speed

There are factors, however, that do affect how many shots per second the camera can take. Having a high-megapixel sensor with its comparatively large amount of data used to mean a slower camera. Yet this is not true of the 30D. Like the 20D, the 30D can take pictures at a speedy 5 frames per

second (fps), but it adds another feature, a second speed of 3 fps. Even at maximum resolution, the camera has a burst duration of 30 JPEG or 11 RAW frames (this will occur only with the fastest memory cards). It is even designed to keep up with autofocus (AF). The camera itself has very fast response times: 0.15-second startup (25% faster than the 20D), 65-millisecond (ms) lag time for shutter release, and finder blackout (when the mirror is up during exposure) of only 110 ms (due to a high-speed mirror drive).

During continuous shooting, each image is placed into a buffer (special temporary memory in the camera) before it is recorded to the memory card. The faster the memory card, the faster the buffer will be emptied, allowing more images to be taken in sequence (this is only up to a point, however; if a card is faster than the camera is capable of working, the card will not change the camera's speed). If the buffer becomes full, the camera will stop shooting until the card writing can catch up. You will then see a *buSY* message on the LCD Panel and in the viewfinder.

Picture Styles

In addition to the optimizing technology of DIGIC II, you can choose specific ways in which the camera will perform further image processing. This can be especially helpful if you are printing image files directly from the camera without using a computer, or when you need to supply a particular type of image to a client.

In the Canon EOS 20D, you could choose Processing Parameters to affect how the image was processed in-camera before being saved to the memory card as a JPEG file (these parameters were tagged to a RAW file's meta-data, too, but could only be read by Canon image processing software). The Canon EOS 5D, 20D, and 30D all use Canon's proprietary DIGIC II processor (explained in more detail on page 54) that acts to optimize the image for JPEG files. In addition, you can choose specific ways

in which the camera will perform further image adjustment. This can be especially helpful if you are printing image files directly from the camera without using a computer, or when you need to supply a particular type of image to a client.

The EOS 5D changed the "Parameters" of the 20D into more photographic and intuitive Picture Styles and the 30D follows this change. You gain access to these Shooting Styles through the Shooting menu ◘ . Press MENU, JUMP to the ◘ , then scroll with the Quick Control Dial ◌ to *Picture Style*, and press the SET button ⓢⓔⓣ —use the ◌ to further scroll and select among the different options. Press JUMP to change details of the menus seen. To return to the ◘ screen at any time, press the MENU again.

All of the Picture Styles have specific effects by default, but you can also change them to create your own, custom effects. Each style controls the degree of in-camera image processing applied to four aspects of an image (they are also in this order on the setting screen): Sharpness, Contrast, Saturation, and Color tone. For black and white (monochrome), Saturation and Color tone are removed (replaced with an N).

Sharpness refers to the amount of sharpening that is applied to the image file by the camera. Contrast will increase or decrease the contrast of the scene that is captured by the camera. Saturation influences color richness or intensity. Color tone helps the photographer decide how red or how yellow to render skin tones, but will also affect other colors as well.

The default styles with their default settings are: *(note that some of the things the camera does for the setting are not controlled by the adjustable sharpness, contrast, and color settings)*

- **Standard** – This makes the image look sharp and crisp. It is the only style available for the Full Auto mode. In-camera sharpening is moderate.

The 30D has several preset Picture Styles for various situations, such as portraits, making it easier to achieve a desired effect without having to adjust each individual setting.

- *Portrait*—This is biased toward making skin tones look attractive. The image is not as crisp as Standard, though still sharp. You can adjust the skin tone further by changing the Color Tone setting.
- *Landscape*—This style is biased toward very sharp and crisp landscape photos, as well as vivid blues and greens.
- *Neutral*—Choose this style for natural colors that are less vivid and intense. No sharpening is applied.
- *Faithful*—This style is rather unique. It is designed specifically for photographing a subject under specific daylight conditions with a color temperature of 5200 K (approximately midday in full sun). The color is adjusted to match the color temperature precisely. No sharpening is applied.
- *Monochrome*—Another word for black and white (technically, you can have a full-color image that is monochro-

matic, meaning it only has one color, but often mono-chrome is substituted for black-and-white as it is here). This completely changes color to black-and-white for JPEG, but RAW images can still be processed as color photos. It is identical to the 20D's monochrome setting.

• **User Defined 1-3**—This allows you to create custom Picture Styles.

When Changing Picture Style Settings

Sharpness, Contrast, and Saturation are pretty intuitive. Be wary of pushing Sharpness or Saturation to their maximum intensity (all the way to the right). This can create images that are difficult to deal with when they are imported into the computer. Color Tone is specifically optimized for skin tone. Settings to the left of center are more red, to the right, more yellow.

While specific situations may affect where you place your control points for the these flexible options, here are a couple of suggestions to consider:

• **Create a hazy or cloudy day setting**—Make one of the parameter sets capture more contrast and color on days where contrast and color are weak. Increase the scale for Contrast and Saturation by one or two points (experiment to see what you like when you open the files on your computer or use the camera for direct printing). You can also increase the red setting of Color tone (adjust the scale to the left).

• **Create a Velvia (an intensely colored slide film) look**—Increase Contrast two points, Sharpness one point, and Saturation by two points.

You can even download customized Picture Style files from the Camera Window software included in the box your 30D came in. Canon also says Picture Styles will be downloadable from their website (www.consumer.usa.canon.com), but as of the printing of this book, they were not there yet. If you want to regularly change Picture Styles, you can use Custom Func-

tion (C.Fn)-01-2; then pressing the SET button ⒮ⒺⓉ while you are shooting displays the Picture Style setting screen. Clearing settings in the Set-up menu ⓎⓉ will put all settings back to their defaults.

You cannot choose or change Picture Styles in any of the 30D's Basic Zone modes: Portrait and Landscape automatically use their respective styles, and the Standard style is set for Full Auto, Close-Up, Sports, Night Portrait, and Flash Off.

Changing Monochrome Settings

You can adjust black-and-white parameters in the Monochrome Picture Style, too. Contrast and Sharpness are the same adjustments as used with the other settings. In addition, there are Filter effect and Toning effect.

The parameters for Filter effect offer four tonal effects that mimic what different colored filters do with panchromatic black-and-white film. A fifth setting, N:None, means no filter effects are applied. Each color choice in the Filter effect menu will make colors similar to your color selection look lighter, and colors opposite it on the color wheel will record darker.

Ye:Yellow is a modest effect that darkens skies slightly and gives what many black-and-white aficionados consider the most natural looking of black-and-white filters. *Or:Orange* is next in intensity, but is better explained if you understand the use of red. *R:Red* is dramatic, making rather light anything that is red, such as flowers or ruddy skin tones, while blues become dark. Skies turn quite striking and sunlit scenes gain in contrast (the sunny areas are warm-toned and the shadows are cool-toned, so the warms get lighter and the cools get darker). *Or:Orange* is in-between yellow and red. The last filter effect is *G:Green*. This makes Caucasian skin tones look more natural and foliage gets bright and lively in tone. Of course, the great thing about digital is that if you aren't sure what any of these do, you can take the picture and see the effect immediately on the LCD Monitor.

Toning effect adds color to the black-and-white image so it looks like a toned black-and-white print. Your choices include N:None, S:Sepia, B:Blue, P:Purple, and G:Green. Sepia and blue are the tones we are most used to seeing in such prints.

White Balance

White balance is an important digital camera control. It addresses a problem that has plagued film photographers for ages: how to deal with the different color temperatures of various light sources. While color adjustments can be made in the computer after shooting, especially when shooting RAW, there is a definite benefit to setting white balance properly from the start.

The 30D helps you do this with an advanced Auto white balance control **AWB** (the same as the 20D's) that makes colors more accurate and natural than earlier D-SLRs. In addition, improved algorithms and the DIGIC II processor make Auto white balance more stable as you shoot a scene from different angles and focal lengths (which is always a challenge when using automatic white balance).

While **AWB** will give excellent results in a number of situations, many photographers find they prefer the control offered by presets and custom settings. With nine separate white balance settings, plus white balance compensation and bracketing, the ability to carefully control color balance is greatly enhanced in the 30D. It is well worth the effort to learn how to use the different white balance functions so that you can get the best color with the most efficient workflow in all situations (including RAW). This is especially important in strongly colored scenes, such as sunrise or sunset, which can fool Auto white balance.

The basic settings are simple enough to learn that they should become part of the photography decision-making process (however, they can only be used with the Creative Zone exposure

modes, see page 115). The more involved setting for Custom white balance ![] is also a valuable tool to understand and use for rendering the truest color in all conditions.

Set white balance by pressing the AF•WB button on the top right of the camera (you don't have to hold it down) Then rotate the Quick Control Dial ◯ to select the desired icon from the LCD Panel.

What is Color Temperature?

You will see white balance referenced to as color temperature. In a simplified manner, this is a scale starting at 0 that represents the color of a heated object as it gives off light. The scale is called the Kelvin scale, which is designated by a K after a number for degrees Kelvin (the convention for Kelvin is not to use the degrees symbol, however). Color temperature is best understood if you compare two numbers. A higher number is always cooler than a lower number. If you have a white balance that matches a particular number, the color of the light will be neutral, and any light lower in temperature will be warm (orangish) while lights higher in temperature will be cooler (bluish). The color temperatures listed for the following settings show the particular color temperature each setting is balanced for (i.e., will make that light neutral).

Camera Settings

AWB Auto: Color temperature range of approximately 3000 – 7000K

This setting examines the scene for you, interprets the light it sees (in the range denoted above) using the DIGIC II processor (even with RAW), compares the conditions to what the engineers have determined works for such readings, and sets a white balance to make colors look neutral (i.e., whites appear pure, without color casts, and skin tones appear normal).

Auto can be a useful setting when you are moving quickly from one type of light to another, or whenever you hope to get neutral colors and need to shoot fast. Even if it isn't the perfect setting for all conditions, it will often get you close

The AF•WB button located above the LCD Panel gives you easy access to change the white balance setting. It is especially helpful if you are in a situation where the light changes, for example, from bright sun to shade.

enough so that only a little adjustment is needed later using your image-editing software.

However, if you have time, it is often better to choose from the white balance settings listed below, because colors will be more consistent from picture to picture. While Auto is well-designed, it can only interpret how it "thinks" a scene should look, so if your wide-angle and telephoto shots of the same subject change what is seen by the camera in terms of colors, the camera will readjust for each shot, often resulting in inconsistent color from shot to shot.

☀ **Daylight**: Approximately 5200K
This setting adjusts the camera to make colors appear natural when shooting in sunlit situations between about 10 A.M. and 4 P.M. (middle of the day). At other times, when

the sun is lower in the sky and has more red light, the scenes photographed using this setting will appear warmer than normally seen with our eyes. It makes indoor scenes under incandescent lights look very warm indeed.

Shade: Approximately 7000K
Shadowed subjects under blue skies can end up very bluish in tone, so this setting makes the light look more neutral or even warms it up. The Shade setting is a good one to use anytime you want to warm up a scene (especially when people are included), but you have to experiment to see how you like this creative use of the setting.

Cloudy: Approximately 6000K
Even though the symbol for this setting is a cloud, its full name is actually the Cloudy/twilight/sunset setting. It warms up cloudy scenes as if you had a warming filter, making sunlight appear warm, but not quite to the degree that the Shade setting does. You may prefer the Cloudy setting to Shade when shooting people since the effect is not as strong. Both settings actually work well for sunrise and sunset, giving the warm colors that we expect to see in such photographs. However, the Cloudy setting offers a slightly weaker effect. You really do have to experiment a bit when using these settings for creative effect. Make the final comparisons on the computer.

Tungsten Light: Approximately 3200K
Tungsten Light is designed to give natural results with quartz lights (which are generally balanced to 3200K). It also reduces the strong orange color that is typical when photographing lamp-lit indoor scenes with daylight balanced settings. Since this control adds a cold tone to other conditions, it can also be used creatively for this purpose (to make a snow scene bluer, for example).

White Fluorescent Light: Approximately 4000K
The Auto setting often works well with fluorescents but, under many conditions, the White Fluorescent Light setting is more precise and predictable. Fluorescent lights usually

appear green in photographs, so this setting adds magenta to neutralize that effect. (Since fluorescents can be extremely variable, and since the 30D has only one fluorescent choice, you may find that precise color can only be achieved with the Custom white balance setting.) You can also use this setting creatively anytime you wish to add a pinkish warm tone to your photo (such as during sunrise or sunset).

⚡ Flash: Approximately 6000K
Light from flash tends to be a little colder than daylight, so this warms it up. According to Canon tech folks, this setting is essentially the same as Cloudy (the Kelvin temperature is the same); it is simply labeled differently to make it easier to use. I actually use both Flash and Cloudy a lot, finding them to be good, all-around settings that give a slight but attractive warm tone to outdoor scenes.

Custom: Approximately 2000-10,000K
A very important tool for the digital photographer, Custom is a setting that even pros often don't fully understand. It is a very precise and adaptable way of getting accurate or creative white balance. It has no specific white balance K temperature, but is set after measuring a specific neutral tone in the light to be photographed. It deals with a significantly wider range than Auto, and that can be very useful.

With the Custom setting, you choose a white (or gray) target and have the camera white balance on it. First, take a picture of something white (or a known neutral tone) that is in the same light as your subject. You can use a piece of paper or a gray card. It does not have to be in focus (even though Canon's manual implies that it does), but it should fill the image area. Be sure the exposure is set to make this object gray to light gray in tone, and not dark (underexposed) or washed out white (overexposed).

Then, go to the Shooting menu **📷** , choose *Custom WB* using the Quick Control Dial ⊙ and push the SET button ⑤ . The last shot you took (the one for white balance) should be displayed in the LCD Monitor. Otherwise, use the ⊙ to

choose the image you shot of the white or gray object. Push (SET) again and the white balance is adjusted to that shot. A note appears, "Set WB to (symbol)", as a reminder.

Now you can use this registered Custom setting by going to the AF•WB button and choosing the Custom icon ☑. You have created a new white balance setting that will stay associated with the Custom choice until you repeat this process for a new subject.

The procedure just described produces neutral colors in some very difficult conditions. However, if the lighting is mixed in color, like a situation where the subject is lit on one side by a window and on the other by incandescent lights, you will only get neutral colors for the light that the white card was in. Also, when shooting in reduced spectrum lights, such as sodium vapor, you will not get a neutral white under any white balance setting.

You can also use Custom white balance ☑ to create special color for a scene. In this case, you white-balance on a color that is not white or gray. You can use a pale blue, for example, to generate a nice amber color. If you balance on the blue, the camera adjusts the color to neutral, which in essence removes blue, so the scene will have an amber cast. You can use different strengths of blue for varied results. You could use any color you want for white balancing—the camera will work to remove (or reduce) that color, which means the opposite color will become stronger (for example, using a pale magenta will increase the green response).

K **Color Temperature**: Set Kelvin temperature (2800-10,000K) This setting offers a wide range of possibilities and is recommended for film photographers experienced in using a color-temperature meter and color-compensation (CC) filters. In addition, it can be used in any situation where you want to warm up or cool down the image. It is a multi-step adjustment. After pressing the AF•WB button and selecting [Kelvin temperature icon] on the LCD Panel using the Quick Control Dial ○ , press MENU and then JUMP to get into the Shoot-

ing menu ⬛ . Then choose *Color Temp.* and press the SET button ⒮⒠⒯ . Next, turn the ◯ once more to select your desired color temperature, pressing the ⒮⒠⒯ to lock-in your choice.

Note: Many pro photographers have used color temperature meters in the past. Unfortunately, various meters do not read color temperature exactly the same. The Kelvin numbers for the 30D's white balance settings are approximate and cannot be precisely related to a different device's color temperature readings.

White Balance Correction

Like the 20D and 5D, the 30D goes beyond the capabilities of many cameras in offering control over white balance—there is actually a white balance correction feature built into the camera. You might think of this as exposure compensation for white balance. It is like having a set of color balancing filters in four colors (blue, amber, green, and magenta) and in varied strengths. Photographers accustomed to using color conversion or color correction filters will find this feature quite helpful in getting just the right color.

The setting is pretty easy to manage using the Multi-controller ❖ . First, go to the Shooting menu ⬛ , scroll to *WB SHIFT/BKT* with the Quick Control Dial ◯ and press the SET button ⒮⒠⒯ . A menu screen will appear with a graph that has a horizontal axis from blue to amber (left to right) and a vertical axis from green to magenta (top to bottom). You move a selection point within that graph with the ❖ . You will see a visual indication on the graph as you change the position of the selection point and, at the same time, an alphanumeric display is visible in the upper right of the screen showing a letter for the color (*B,A,G,* or *M* for the colors) and a number for the setting. For photographers used to color-balancing filters, each increment of color adjustment equals 5 MIREDS of a color-temperature changing filter (a MIRED is a measuring unit for the strength of a color temperature conversion filter). Remember to set the correction back to *zero* when conditions change.

Shooting an image in RAW gives you the flexibility to change the white balance on the computer after you have taken the shot. This can be a corrective or creative tool.

White Balance Auto Bracketing

When you run into a difficult lighting situation and want to be sure of the best possible white balance settings, another option is white balance auto bracketing. This is actually quite different than autoexposure bracketing. With the latter, three separate exposures are taken of a scene, whereas with white balance auto bracketing you take just one exposure and the camera processes it to give you three different white balance options.

Note: Using white balance bracketing will slightly delay the recording of images to the memory card. What is happening is that the camera is processing the shot three times. You cannot use white balance bracketing with your image-recording quality set to RAW or RAW+JPEG.

This bracketing is done up to +/- 3 levels (again, each step is equal to 5 MIREDS of a color correction filter). You can

bracket from blue to amber or from green to magenta. Keep in mind that even at the strongest settings, the color changes will be fairly subtle.

The white balance bracketing will be based on whatever white balance mode you have currently selected. The selected mode's icon will blink to tell you that white balance bracketing is being used. You access white balance bracketing by selecting *WB SHIFT/BKT* in the Shooting menu ○ and pressing the SET button ⓢⓔⓣ . A graph screen with the horizontal (blue/amber) and vertical (green/magenta) axes will appear on the LCD Monitor. Rotate the Quick Control Dial ○ to adjust the bracketing amount to the right (clockwise) to set the blue/amber adjustment then back to zero and go to the left (counter clockwise) for green/magenta (press ⓢⓔⓣ after each of the color-scale adjustments). You can also shift your setting from the center point of the graph by using the Multi-controller ✤ .

Note: The default for white balance bracketing records an original image at the currently selected white balance setting, then internally creates an additional set of (1) a bluer image and a more amber image, or (2) a magenta and greener image. Use Custom Function (C.Fn)-09 to change bracketing sequence.

The obvious use of this feature is to deal with tricky lighting conditions. However, it has other uses as well. You may want to add a warm touch to a portrait but are not sure how strong you want it. You could select the Cloudy setting, for example, then use white balance bracketing to get the tone you're looking for (the bracketing will give you the standard Cloudy white-balanced shot, plus versions warmer and cooler than that). Or, you may run into a situation where the light changes from one part of the image to another. Here, you can shoot the bracket then combine the white balance versions using an image-processing program (i.e., take the nicely white-balanced parts of one bracketed photograph and combine them with a different bracketed shot that has good white-balance in the areas that were lacking in the first photo).

RAW and White Balance

Since the RAW format allows you to change white balance "after the shot," some photographers have come to believe that it is not important to select an appropriate white balance at the time the photo is taken. While it is true that Auto white balance and RAW will give excellent results in many situations, this approach can cause consistency and workflow challenges. White balance choice is important because, when you bring CR2 files into software for "translation," the files come up with the settings based on what you chose during initial image capture (I use the word based because this changes depending on the software—Canon software will use the settings exactly, while Adobe Camera Raw, for example, is an interpretation of the settings).

Sure you can edit white balance settings in the computer, but why not make a good RAW image better by merely tweaking the white balance with minor revisions at the image-processing stage rather than starting from an image that requires major correction? There will be times that getting a good white balance setting is difficult, and this is really when the RAW software white balance correction can be a big help.

File Formats

The Canon EOS 30D records images as either JPEG or RAW files. It is important to understand how the sensor processes an image. It sees a certain range of tones coming to it from the lens. Too much light, and the detail is washed out; too little light, and the picture is dark. This is analog (continuous) information, and it must be converted to digital (which is true for any file format, including RAW or JPEG). The complete data is based on 12-bits of color information, which is changed to 8-bit color data for JPEG, or simply placed virtually unchanged into a 16-bit file for RAW. (A bit is the smallest piece of information that a computer uses—an acronym for binary digit. Data of eight bits or higher are required for true photographic color.) This occurs for each of three different color channels employed by the 30D: red,

green, and blue. RAW files have very little processing applied by the camera. The fact that they contain 12-bit color information is a little confusing since this information is put into a file that is actually a 16-bit format.

Both 8-bit and 16-bit files have the same range from pure white to pure black because that range is influenced only by the capability of the sensor. If the sensor cannot capture detail in areas that are too bright or too dark, then a RAW file cannot deliver that detail any better than a JPEG file. It is true that RAW allows greater technical control over an image than JPEG, primarily because it starts with more data (12-bits in a 16-bit file), meaning there are more "steps" of information between the white and black extremes of the sensor's sensitivity range. These steps are especially noticeable in the darkest and lightest areas of the photo, allowing you to pull more detail from those areas. So it appears the RAW file has more exposure latitude and greater adjustment to the image is possible before banding or color tearing becomes noticeable.

JPEG format compresses (or reduces) the size of the image file, allowing more pictures to fit on a memory card. The JPEG algorithms carefully look for redundant data in the file (such as a large area of a single color) and remove it, while keeping instructions on how to reconstruct the file. JPEG is therefore referred to as a "lossy" format because technically, data is lost. The computer will rebuild the lost data quite well as long as the compression is low.

It is essential to note that both RAW and JPEG files can give excellent results. Photographers who shoot both use the flexibility of RAW files to deal with tough exposure situations, and the JPEG file when they need fast and easy handling of images. Which format will work best for you? Your own personal way of shooting and working should dictate that. If you are dealing with problem lighting and colors, for example, RAW will give you a lot of flexibility in controlling them. If you can carefully control your exposures and keep images consistent, JPEG will be more efficient.

RAW Exposure Processing

JPEG processing is easy. You can do it with any image-processing program. However, not all such programs can open RAW files; special software is required to convert from RAW. Canon does supply a dedicated software program with the 30D called EOS Viewer Utility. It is specifically designed for CR2 files and allows you to open and smartly process them. You can also choose other processing programs that make converting from RAW files easier, such as Phase One's C1 software, Bibble, or Adobe Camera RAW. These independent software programs are often intended for professional use and can be expensive. Their advantage tends to be ease-of-use for better processing decisions, although Canon's included Digital Photo Professional (DPP), a high-level RAW conversion program, is quite powerful.

The disadvantage of most RAW conversion programs is that they are not integrated into any image-editing software. This means you have to open and work on your photo, then save it and reopen it in an editing program, such as Photoshop. Adobe met this challenge by including RAW conversion capabilities in Photoshop CS (there is a RAW plug-in available that works similarly for earlier versions) and in Photoshop Elements 4.0. This means you can open a RAW file directly in either of these programs, do the conversions, and then continue to work on the file without leaving the program. You will have to update your Camera Raw software if you have had it for a while, since the 30D's CR2 file is a recent version not included in the original CS program (check for updates at www.adobe.com). Workflow is much improved and control over the RAW file is quite good, although some photographers still prefer the conversion algorithms of other programs.

Whatever method you choose to gain access to RAW files in your computer, you will have excellent control over the images in terms of exposure and color of light. There is special metadata (shooting information stored by the camera) in the file containing the exposure settings you selected at the time of shooting – this is used by the RAW conversion pro-

gram when it opens an image. You can then change these exposure values without causing harm to the file. Most RAW software allows batch processing. This allows you to adjust a group of photos to specific settings and can be a very important way to deal with multiple photos from the same shoot.

Improved RAW Conversion Software

While RAW can be important for many photographers, Canon's RAW conversion software left a lot to be desired in the past. Canon has responded to the requests and complaints of photographers to develop a far superior RAW program, Digital Photo Professional (DPP). This software speeds processing quite noticeably.

A key feature is the ability of the program to save adjustments to a file that can then be reloaded and applied again to the original or to other RAW files. The program includes a whole range of valuable controls, including tone curves, exposure compensation, white balance, dynamic range, brightness, contrast, color saturation, ICC Profile embedding, and more. There is also a comparison mode that allows original and edited images to be compared side by side or in a split image.

DPP even has some batch processing features. It can allow continuous work on images while other files are rendered and saved in the background. Once images have been adjusted in DPP, they can be immediately transferred to Photoshop. There is no question that DPP will really help streamline the workflow of any photographer who needs to work with RAW.

Image Size and Quality

The EOS 30D offers a total of 13 choices for image-recording quality, consisting of combinations of different file formats, resolutions, and compression rates. But let's be straight about this, most photographers will shoot the maximum image size using the RAW or the highest-quality JPEG setting. There is little point in shooting smaller image sizes except for specialized purposes. After all, the camera's high resolution is what you paid for!

All settings for recording quality are selected in the Shooting menu ▣ under *Quality*. Press the SET button ⒮ⒺⓉ and the JPEG settings appear in the left-hand column, showing a symbol and a letter. The letter stands for the resolution size of the image file. The most important settings are L (the largest image size for JPEG, 8.2 megapixels) and RAW. RAW is always 8.2 megapixels.

The symbol depicts the level of compression. The shape with the smooth curve ◢ represents the least amount of compression (Fine = better quality), and when combined with L, makes a very high quality image. The symbol with a stair shape ◢ illustrates higher compression (Normal = lesser quality), giving a good quality JPEG image, but not as good as the Fine setting.

The 30D can record both RAW and JPEG simultaneously. Six different RAW+JPEG choices represent both Fine and Normal compression levels for each separate resolution of JPEG (L, M, S), and can be seen in the right-hand column of the menu screen. They can be useful for photographers who want added flexibility. These settings record images using the same identification numbers, but with different formats designated by their extensions, .jpg for JPEG and .cr2 for RAW. You can then choose JPEG, for example, for direct printing, quick usage, and to take advantage of the DIGIC II processor. And you still have the RAW file for use when you need its added processing power.

RAW+ ◢ L is a key choice because you gain the best quality with the whole 8.2 megapixels in both formats. RAW+ ◢ S is useful for photographers who need to display a quick JPEG file for reference or to post on the web. This gives the full RAW file, plus a 2-megapixel JPEG file. These are the most commonly used RAW+JPEG files. The other combinations offer different options for resolution plus compression, but are mostly curiosities for most photographers and usually useful only in specialized situations.

High-quality images can make the detail look fantastic, whether the ⇨
images are displayed large or small.

The RAW file will first appear in your RAW conversion software with the same details of processing as the JPEG file (including white balance, color matrix, and exposure), all of which can be easily changed in the RAW software. Though RAW is adaptable, it is not magic—you are still limited by the original exposure as well as the tonal and color capabilities of the sensor. Simply because RAW gives you more options to control the look of your images, it is not an excuse to become sloppy in your shooting. If you do not capture the best possible file, your results will be less than the camera is capable of producing.

Each choice does influence how many photos can fit on a memory card. Most photographers will be shooting with large memory cards because they will want the space required by high-quality files on this camera. It is impossible to give exact numbers of how many JPEG images will fit on a card because this compression technology is variable. You can change the compression as needed (resulting in varied file sizes), but remember, JPEG compresses each file differently depending on what is in the photo and how it can be compressed. For example, a photo with a lot of detail will not compress as much as an image with a large area of solid color.

That said, you may use the chart on page 77 to give you an idea of how large these files are and how many images might fit on a memory card of 1 gigabyte (GB)—the figures are based on actual numbers produced by the camera using such a card (JPEG values are always approximate). Also, the camera does use some space on the card for its own purposes, so you do not have access to the entire capacity of 1 GB for image files.

You can immediately see one advantage that JPEG gives over RAW in how a memory card is used. The highest-quality JPEG file at the full 8.2 megapixels allows you to store nearly 3.3 times the number of photos compared to what you could when shooting RAW.

File Sizes and Card Capacity

Image Size	File Size	Approximate Shots on 1 GB card
L	3.6 MB	240
L	1.8 MB	480
M	2.2 MB	420
M	1.1 MB	830
S	1.2 MB	730
S	0.6 MB	1440
RAW	8.7 MB	105
RAW + L	12.3 MB	72
RAW + S	9.3 MB	100

Camera Menus and the LCD Monitor

Using the Menus

The Canon EOS 30D, like all digital cameras, includes a great deal of settings that cannot be programmed for use by buttons and dials on the camera. Digital cameras bring a whole range of controls that were never possible in a film camera. Few photographers use all of them, but all of them have uses for at least some photographers. To get these controls onto the camera, designers must include them in menus that can be displayed on the camera LCD. The large 2.5-inch LCD Monitor of the 30D offers a great benefit for menus because it makes them so much easier to read.

While most controls on the 30D menus will be familiar to digital photographers, Canon has once again made an effort to make them more readable and user-oriented on this new model. Plus there are new controls unique to the 30D. In addition, the 30D menus can be set to any of 15 different languages.

Navigating the Menus

All menu controls, or items, are grouped into three categories, based on their use. These categories, intuitively named in order of appearance within the menu system, are Shooting, Playback, and Set-up. To make them easier to follow, they are also color-coded: red for shooting, blue for playback, and yellow for set-up. You gain access to the 30D's menu screen whenever you push the MENU button, which is located on the back of the camera next to the top left corner of the LCD Monitor.

◁ *The LCD Monitor takes most of the guesswork out of getting a good image, giving you immediate results for on-the-scene adjustments.*

At this point, the Shooting menu ◘ will appear. Move from category to category in one of two ways: push the JUMP button (also on back of camera to left of LCD Monitor) to move immediately to the first item in the next category in order, or scroll down the items within any category to the bottom and the menu items will automatically roll over to the next category.

These category menus are designated by their icon at the top of the menu screen on the LCD Monitor. You actually see two icons; one at the top left of the screen for the category presently in use, and the next category's icon at the top right. Once in a menu category, rotate the Quick Control Dial ◯ to select desired items and sub items, and press the SET button (ᴤᴇᴛ) to confirm, or lock-in, these item choices. You can also use the Main Dial 🖧 (by the shutter release button) to move through the menu items. To get out of the menus, you can press the MENU, but it is just as easy and probably more efficient from a shooting standpoint to press the shutter release slightly.

◘ Shooting Menu

For items that obviously affect actual photography, this red-coded menu includes ten choices:

Quality (set image size and resolution, plus RAW)
Red-eye On/Off
Beep (signal for controls on or off)
Shoot w/o card (this allows you to test the camera when no memory card is in it)
AEB (auto exposure bracketing in 1/3 stop increments)
WB SHIFT/BKT (for bracketing and shifting white balance in nine levels)
Custom WB (manually set white balance)
Color temp. (manually set color temperature)
Color space (sRGB or Adobe RGB)
Picture style (similar to the old "Parameters" in the EOS 20D, but uses photo subjects and styles to set up different profiles for processing images in-camera)

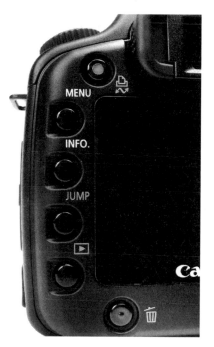

The MENU button, located to the left of the LCD, gives you access to the Shooting, Set-up, and Playback Menus.

Note: Not all menu items will display when the camera is in the Full Auto mode.

▶ Playback Menu

Offers eight choices used when viewing images on the LCD Monitor. This blue-coded menu includes:

Protect images (prevents images from being erased unless the card is formatted)

Rotate (rotate image so vertical will display vertically)

Print Order (creates instructions for images to be printed DPOF)

Transfer order (selects which images are transferred to computer)

Auto Play (automatic "slide show" on LCD Monitor changes image every 3 seconds)

Review time (how long image stays on LCD Monitor after shot)

AF Points (turns on or off their display in the viewfinder)

Histogram (choose between Bright (luminosity) and RGB histograms)

⚙ Set-Up Menu

This menu is coded yellow. It offers 14 selections to make before shooting.

Auto power off (controls when the camera turns itself off when it is not used for a certain time)

Auto rotate (affects how verticals are displayed in the LCD Monitor)

LCD brightness (choose from five levels)

Date/Time

File numbering options (three options to affect how files are numbered by the camera)

Select folder (lets you create and select folders on the memory card)

Language (15 options)

Video system (for playback of images on a TV)

Communication (for communication with a printer or computer)

Format (very important, used to initialize and erase the card)

Custom Functions (C.Fn)

Clear settings (settings go back to default)

Sensor clean

Image transfer (LAN) settings (only used when wireless transmitter WFT-E1/E1A is attached to camera)

Firmware Ver. (used when updating camera's operating system)

Understanding the menu system is necessary in order to gain full benefit from using the LCD Monitor and the Custom Functions.

The LCD Monitor

The LCD monitor is one of the most useful tools available when shooting digital, giving immediate access to your images. You can set your camera so that the image appears for review on the LCD monitor directly after shooting the picture. It's better than a Polaroid print! However, the EOS 30D is not a live monitor like that seen on compact or point-and-shoot digital cameras. The standard D-SLR uses a mirror

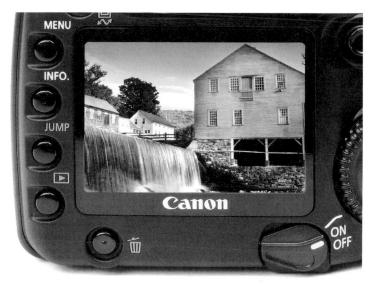

The Playback button ▶ *located at the lower left on the back of the camera controls image review and playback functions.*

to direct the light from the lens to the viewfinder so that the sensor is not active until the exposure (and therefore cannot send an image to the LCD). At exposure, the mirror pops up so the sensor can capture an image from the lens.

The 30D's 2.5-inch color LCD Monitor is a great improvement over earlier digital camera monitors. It is significantly bigger than the old standard of 1.8-inches, with more resolution and more readable at all angles and even in bright light. Canon says it has a viewing angle up to 170°—nearly twice the viewing angle of the 20D. You can adjust its brightness in the Set-up Menu **ⵌ** (select *LCD Brightness* and use the Quick Control Dial ◌ and SET button ⓢ⒠⒯ to adjust the brightness level and confirm), but this may change the monitor in such a way that you will find the image harder to evaluate. The easiest thing to do in order to read the LCD better is shade the monitor in bright light by using your hand, a hat, or your body to block the sun.

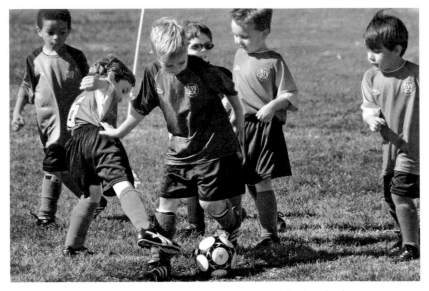

You can set how long you want the camera to display the image you have just taken, which is helpful for those situations where you want to be sure you made a good photo.

LCD Image Review

The 30D's LCD Monitor is used strictly for review and editing. Like most D-SLRs, the camera does not have the capability of LCD viewing while shooting. You can choose to instantly review the image you have just shot, and you can also look at all of the images you have stored on your CF card. Most photographers like the instant feedback of reviewing their images because it gives a confirmation that the picture is okay.

You need to set the length of time needed to review the images you have just captured. It is frustrating to be examining a picture and have it turn off before you are done. You can set the duration from among a several choices that include *2 sec, 4 sec, 8 sec,* or *Hold,* all controlled by the *Review time* selection in the Playback menu ▶ (color code

Blue). You also use this menu item to activate the *Off* option, which saves power by turning off the LCD Monitor, but does not allow you to review the images (this does not affect playback of images, but only the review right after a picture is taken).

A setting of *2 sec.* is a bit short. You can't really evaluate anything in that time other than you got a picture. To me, if one doesn't want the monitor on long, then turn the monitor Off. I recommend *8 sec.* You can always turn the review off sooner by pressing the Shutter button. The *Hold* setting is good if you like to study your photos, because the image for review remains on the LCD Monitor until you press the Shutter button. But be careful, it is easy to forget to turn off the monitor when using this selection, in which case your batteries will wear down.

Note: There is a trick not detailed in the camera manual that lets you "hold" the image even when the duration is not set to *Hold*. As the image appears for review, press the trash icon 🗑 (normally used for erasing) located below the left corner of the LCD Monitor on the back of the camera. This will leave the image on as long as you want. Ignore the *OK* and *Cancel* commands (you are not trying to erase the image yet). Press the Shutter button to turn the review image off.

Playback
Reviewing images on the LCD Monitor is an important benefit of digital cameras. To see not only your most immediate shot, but also any (or all) of the photos you have stored on the CF card, press the Playback button ▶ on the back of the camera to the left of the LCD Monitor. The last image you captured will show on the LCD Monitor. You then move from photo to photo by rotating the Quick Control Dial ◌ , either counterclockwise to view images in a sequence from most recent to first captured, or clockwise to view from first shot to most recent.

Note: Buttons and other controls on the camera with blue-colored words or icons refer to playback functions.

With the 30D, you can display the review or playback image in three different forms on the LCD by progressively pushing the INFO button, also found on the back of the camera to the left of the LCD Monitor:

1. **Display with basic information**—The image for review covers the entire LCD screen and includes superimposed data for folder number, image number, quantity of shots on the CF card, shutter speed, and aperture.

2. **Display with full shooting information**—A thumbnail of the image is shown with a histogram and expanded data about how the image was shot (such as the date and time, white balance, ISO speed, image recording quality, exposure, and more); this can be very useful for checking what settings are working for you. The thumbnail also includes a Highlight alert function that blinks where areas are overexposed.

3. **Display with no information**—This shows only the photo with no additional information. The image again covers the whole LCD Monitor, but only the image appears.

Pressing the Shutter button halfway will stop playback by turning the LCD Monitor off, making the 30D ready to shoot again. You can also stop the playback and turn the LCD Monitor off by pressing the ▶ .

Automatic Image Rotation
As in all Canon EOS D-SLRs, you can choose to automatically rotate vertical images during review or playback so they appear up-and-down rather than sideways in the LCD Monitor when the camera is held in a horizontal position. To select the *Auto rotate* command, go to the Set-up menu 𝖄𝖳 and use the Quick Control Dial ◎ and SET button ⓢⓔⓣ . Then choose the first *On* setting, again using the ◎ and ⓢⓔⓣ . To rotate any image later, you need to choose *Rotate* in the Playback menu ▶ .

This feature makes amateurs comfortable, but is not a very professional feature. Sure, the image is upright and you don't have to rotate the camera to view it. The problem is the size of the image. To get that vertical image to fit in the horizontal frame of the LCD Monitor, the picture has to be reduced considerably and becomes harder to see.

I used to always keep *Auto rotate* off so the largest image possible showed up in the LCD Monitor, even if I do have to rotate the camera to see it properly. However, this meant that I always had to rotate images in the computer. The 30D expands the choices for this control: auto rotate for both camera and computer *On* 🔾 🖥️ , rotate for computer only, *On* 🖥️ (new feature to EOS D-SLRs), and Off. I really like the "rotate for computer only" option, *On* 🖥️ , as the image displays full-LCD size, and rotates on the computer (only with programs that recognize this command in the file's metadata).

Magnifying the Image

You can make the image larger on the LCD Monitor by factors of 1.5x to 10x. This feature can help you evaluate sharpness and exposure details. Press the Enlarge button ⊕ (located on back of camera in top right corner—marked by a blue magnifier with a plus sign) repeatedly to progressively magnify the image. Press the Reduce button ▦·⊖ (marked by a blue magnifier with minus sign), located to the immediate left of the ⊕ , to shrink the magnification. You quickly return to full size by pushing the Playback button ▶ .

Use the Multi-controller ⁛ to scroll around the magnified image in order to look at different sections of the picture. The Quick Control Dial ◯ will move from one image to another at the same magnified view so you can compare sharpness at a particular detail, for example.

The 30D adds a new feature for magnifying images that was not possible in the 20D. When an image came up for review in the 20D, I often wanted to check a detail. You could not magnify that review image, so you'd have to press

Playback and enlarge then. Now with Custom Function C.Fn-17, Magnified view, you can tell the camera you want to enlarge the review image immediately after a photograph is taken. Then during review, hold down the Print/Share button ⬜ (to the left of the viewfinder eyepiece) and press ⊕ to magnify the image. The AF point selector ⊞ enlarges and the AE lock button ✳ reduces the image.

File Numbering for Images

Image files on your memory card are automatically numbered from 0001 to 9999. However, the EOS 30D gives you several options as to how these numbers are applied to the images. Changing numbering can be useful if you are working from multiple memory cards and want to ensure the image file names are distinct. You have three numbering choices: *Continuous*, *Auto reset*, and *Manual reset*. These are all selected in the Set-up menu ❢❢ under *File numbering* after navigating there with the Quick Control Dial ◯ , then SET ⑤ .

Continuous file numbering keeps numbers going in sequence regardless if you change the memory card. This ensures that your numbers are different as they come into the computer from a particular shoot. If you put a memory card into the camera with files already on it, numbering will start as the next higher number from the highest number on the existing images.

Auto reset will make the numbers change and go back to 0001 every time you insert a new memory card. Some photographers like this because it allows them to download and organize images in a similar way even though they come from different cards. Manual reset is, as it sounds, a way for you to force the camera to reset its image numbering. When a reset is performed, a new folder is created and the image number begins with 0001.

One curious thing to know about numbering with the 30D is that if you reach 9999, the LCD Panel and viewfinder will display this warning, *FuLL*. At this point, you cannot record

any new images to that card, even if it has barely been used. You have to go to a new memory card or use *Manual reset*. If you know you are reaching high numbers with your camera, you may want to be sure you use *Manual reset* before you do any important shooting.

Image Protection

This is an underused and underappreciated feature of a digital camera that can really help you. The most important function of Image Protection is to allow you to go through your pictures one at a time on the LCD Monitor, choosing which ones to keep, or "protect", meaning all the rest can be discarded by erasing them all at once.

Protection is very easy to use: go to the Playback menu ▶ and select *Protect*. Press the SET button (SET) and one image will appear in the LCD Monitor with a symbol of a key and the word SET appearing at the top left of the photo. Next go through your photos one by one using the Quick Control Dial ○ and push (SET) for every one that is a potential "keeper." An icon showing a little key will now show at the bottom of the image.

Once you have chosen the protected images, erase all the rest by selecting *All* on the Erase screen (see below). You have now done a quick edit, giving you fewer photos to deal with after downloading to the computer. There is often downtime when shooting, so use it to go through your photos to edit by "protecting" key shots.

Erasing Images

The 30D's process for erasing photos from the memory card is the same as that used by most digital cameras. When an image is displayed on the LCD Monitor from playback, push the Erase button 🗑 located below the left corner of the LCD Monitor. A screen will appear with three options for erasing the image. Turn the Quick Control Dial ○ to highlight the appropriate choice. The first option is *Cancel*, which will cancel this function. Next is *Erase*, which is the most commonly use function here and will erase the image

The Erase button, located below the LCD Monitor, simplifies the editing process, as you can immediately erase the bad ones to make room on the memory card.

being displayed. And last is *All*, to use if you want to delete all unprotected images on the CF card. You can erase images during playback or right after exposure when an image appears in review.

Note: Once an image is erased, it is gone and not easily recovered (there is software available that may be able to recover it if you don't take any more photos that might record over the original files). Make sure you no longer want an image before making the decision to erase it.

TV Playback

If you have a group of people who need to see your photos, and you have access to a television with standard RCA input connectors, you can display images on the TV from the memory card.

First, go to the Set-up menu ⚙ and select the option for Video system. Then, if you are in the US or Canada, be sure to choose NTSC. (For many other parts of the world, you will need to select PAL). Make sure both the camera and television are turned off, then connect the camera to the TV using the cables supplied with the camera. Plug into the Video Out connector on the camera and Video In on the television. Turn the TV on, then the camera. Now press the Playback button ▶ and the image will appear on the TV (but not on the back of the camera). Some TV's will cut off edges of the image.

Custom Functions

Like most sophisticated digital cameras, the Canon EOS 30D can be customized to fit the unique needs and personality of a photographer. This is done through the Custom Functions menu. Some photographers never use these settings, while others use them all the time. The camera won't take better photos by changing these settings, but Custom Functions may make the camera easier for you to use.

The 30D has 19 different built-in Custom Functions (C.Fn), numbered 01-19. They are found in the Set-up menu ▼▼ under the selection for *Custom Functions (C.Fn)*. Use the Quick Control Dial ◎ to get to the C.Fn. option you want (a helpful description of the control's function appears on the LCD Monitor as each is selected). Use SET ⓢⒺⓣ and ◎ to choose the desired custom function. Press MENU to exit this part of the menus and return to the Set-up menu ▼▼ . When you change a Custom Function from the default, a small *C.Fn* will appear on the top LCD panel (except for C.Fn-00). Here is a brief summary and commentary on the various Custom Functions.

C.Fn-01 SET function when shooting
This setting assigns new options for using the SET button.

0. **Default**—the SET button ⓢⒺⓣ works normally, acting like an OK button for menus.
1. **Change quality**—allows you to press ⓢⒺⓣ and go directly to recording quality, changing it with the Quick Control Dial ◎ . (This is useful if you want the ability to quickly change from RAW to JPEG). The settings appear in the LCD Panel.
2. **Change Picture Style**— ⓢⒺⓣ will take you directly to the Picture Style selection screen in the menus.
3. **Menu display**— ⓢⒺⓣ acts like the MENU button (some people find this more convenient).
4. **Image replay**— ⓢⒺⓣ acts like the Playback button ▶ .

C.Fn-02 Long exp. noise reduction

This is three-position switch, which adds noise reduction for long exposures.

0. *Off*— default
1. *Auto noise reduction*—for exposures of 1 sec. or longer, the camera looks for noise and automatically applies noise reduction if found. However, this does add processing time, which may slow the camera; while it is in progress, image playback and menu use is not possible.
2. *On*—noise reduction is applied to all exposures of 1 sec. or longer, even if noise is very low and would not be detected under setting 1. This means every long exposure will likely slow down the camera as it processes it.

C.Fn-03 Flash sync. speed in Av mode

This setting controls the camera-selected flash-sync speed in Av mode.

0. *Auto (default)*—the camera varies the shutter speed to match the ambient light conditions.
1. *1/250 sec. fixed*—the camera always uses 1/250 sec. (This custom function doesn't seem to be particularly useful, since using Manual Exposure (M) mode at 1/250 then changing f/stop would give you the same feature without going through the menu).

C.Fn-04 Shutter/AE Lock button

This controls the functions of the shutter button and AE Lock button ✱ .

0. *AF/AE lock (default)*—focus and exposure are locked when the Shutter button is depressed halfway; exposure is locked with the AE Lock button ✱ .
1. *AE lock/AF*—autofocus is initiated and locked with the ✱ . The Shutter button locks exposure when depressed halfway.
2. *AF/AF lock, no AE lock*—pressing the AE Lock button temporarily interrupts and locks focus in AI Servo AF

mode. The exposure is set when the shutter releases. (This prevents focus from being thrown off if an object passes briefly in front of the camera.)

3. *AE/AF, no AE lock*—lets you start and stop AI Servo AF by pushing ✻ . Exposure is set when the shutter releases.

C.Fn-05 AF-assist beam

This controls the AF-assist beam on a dedicated EOS Speedlite.

0. *Emit (default)*—the AF-assist beam is emitted whenever appropriate.
1. Does not emit—this cancels the AF-assist beam, which can be useful in sensitive, low-light situations.
2. *Only external flash emits*—this cancels AF-assist with the built-in flash, but uses it for external flash.

C.Fn-06 Exposure level increments

This sets the size of incremental steps for shutter speeds, apertures, exposure compensation, and autoexposure bracketing (AEB).

0. *1/3 stop (default)*
1. *1/2 stop*

C.Fn-07 Flash firing

This is used to disable the firing of a flash in sensitive situations.

0. *Fires (default)*—flash fires whenever appropriate
1. *Does not fire*—flash will not fire under any circumstances.

C.Fn-08 ISO Expansion

This expands the ISO range of the camera to 3200.

0. *Off (default)*—ISO expansion is turned off.
1. *On*—this expands the ISO settings to include 3200 (shows as H on the camera)

C.Fn-09 Bracket sequence/Auto cancel

This allows you to set the order of bracketing for exposures and white balance or cancel bracketing.

0. **0, -, +/Enable (default order with auto cancel)**—exposures will be made in this order: metered exposure, underexposure, and overexposure, with auto cancellation (meaning bracketing will be canceled if you change the lens, turn the camera off, or replace the battery or the CF card). White balance will be the set WB, then cooler (more blue) and warmer (more amber) or more magenta and green (the bias is dependent on how you set it up—see page 68 for more on WB bracketing).

1. **0, -, +/Disable (default order without auto cancel)**—exposures will be made in the same order as above but there is no auto cancellation.

2. **-, 0, +/Enable (optional order with auto cancel)**—exposures will be made in this order: underexposure, metered exposure, and overexposure, with auto cancellation. White balance will be cooler (more blue), the set WB and warmer (more amber), or more magenta, the set WB and more green.

3. **-, 0, +/Disable (optional order but no auto cancel)**—this is the same as 2 but with no auto cancellation.

C.Fn-10 Superimposed display

This changes how the AF points appear in the viewfinder.

0. **On (default)**—this illuminates or highlights the appropriate AF point when the camera locks focus (or points, depending on the AF mode).

1. **Off**—turns off the illumination. Some photographers find the illuminated point distracting. The AF point will still light when you select it manually.

Tricky lighting situations, such refections off shiny surfaces, can make achieving the correct exposure more troublesome. Bracketing a shot can help to find the right exposure in any given situation.

C.Fn-11 Menu button display position

This function changes how the menus are presented when you press the MENU button.

0. ***Previous (top if power off)***—this default setting shows the last menu item you looked at ("previous"), but will go to the top of the menu (Quality) if the switch is turned off, the battery is replaced, or the CF card is replaced.

1. ***Previous***—this does the same thing as above, but it always goes to the last menu item even if the camera is turned off.

2. ***Top***—this always displays the top menu screen (Quality).

C.Fn-12 Mirror lockup

This Custom Function turns mirror lockup on or off.

0. *Disable (default)*—the mirror functions normally

1. *Enabled*—the mirror will move up and lock in position with the first push of the Shutter button (press fully). With the second full pressing of the Shutter button, the camera will then take the picture and the mirror will return to its original position. This can minimize camera movement for critical exposures using long telephoto lenses. After 30 seconds, this setting automatically cancels.

C.Fn-13 AF point selection method

This control changes the how AF points are selected manually.

0. *Normal (default)*—the AF point is selected using the AF point selection button and the Multi-controller.

1. *Multi-controller direct*—this setting lets you select AF point using just the Multi-controller ✛ . The AF point selection button ⊡ is used to set the camera back to auto AF point selection.

2. *Quick Control direct*—this lets you use the Quick Control Dial ◯ for AF point selection. However, you must push ⊡ to use the ◯ for exposure compensation.

C.Fn-14 E-TTL II

This is a simple control that lets you choose a different way of metering electronic flash.

0. *Evaluative (default)*—this uses fully automatic Evaluative metering for all conditions.

1. *Average*—this setting averages the flash exposure readings over the entire area covered by the flash.

C.Fn-15 Shutter curtain sync

This is a creative control that determines how motion blurs are rendered in flash photography.

0. *1st-curtain sync (default)*—this is the standard flash sync for most cameras (also called front-curtain sync). The flash goes off at the beginning of the exposure, as

soon as the shutter curtains fully open to expose the whole sensor. At slow shutter speeds, the flash will create a sharp image and motion blur is registered after the flash. With moving subjects, this results in a blur or light trail that appears to be in front of the sharp flash-exposed subject (because the movement forward is after the flash). Such a blur is not natural looking.

1. *2nd-curtain sync*—the flash fires at the end of the exposure (also called rear-curtain sync), just before the second shutter curtain closes. At slow shutter speeds, this results in an ambient light motion blur that looks natural because it trails behind a moving, sharp flash-exposed subject. Don't be alarmed when using this that a flash occurs at the beginning of the sequence—this is a pre-flash used for setting exposure.

C.Fn-16 Safety shift in Av or Tv

You can allow the camera to smartly shift exposure when shooting in Av or Tv modes when the brightness of the scene exceeds the camera's capabilities at the chosen aperture or shutter speed.

0. *Disable (default)*—this locks in the chosen f/stop for Av, or the shutter speed for Tv, regardless of conditions.

1. *Enable*—this choice lets the camera shift f/stop or shutter speed to get a good exposure automatically.

C.Fn-17 Magnified view

This affects when the image on the LCD can be magnified.

0. *Image playback only (default)*—the image can only be magnified from playback.

1. *Image review and playback*—the image can be magnified as normal from playback, but it can also be magnified directly when in review by holding the Print/Share button ⊡ down then pressing the Enlarge button ⊕ .

C.Fn-18 Lens AF stop button function

This is a specialized function to modify how autofocus is controlled by certain telephotos with an AF stop button. If your lens does not have this button, this function is meaningless.

0. *AF stop (default)*—this is simply standard autofocus, but you can stop autofocus by pushing the AF stop button.

1. *AF start*—autofocus operates only when the AF Stop button on the lens is pressed. AF operation with the camera itself will be disabled while the button is pressed.

2. *AE lock while metering*—the AF Stop button locks exposure if it is pressed while metering is still active. This selection is great if you want to meter and focus a scene separately.

3. *AF point M to auto*—holding down the AF Stop button will switch the camera from manual AF point selection to automatic AF point selection, but only while you hold it down.

4. *One shot to AI servo*—this choice enables the AF Stop button to switch the camera from One-Shot AF mode to AI Servo AF mode as long as the button is held down.

5. *IS start*—with the lens' IS switch turned on, the Image Stabilizer only operates when you press the AF Stop button.

C.Fn-19 Add original decision data

This very specialized setting is used by police and other law organizations.

0. *Off (default)*

1. *On*—this turns the feature on so that data for verifying that images are original is added to the image file. To read this data, you need to use the optional Data Verification Kit DVK-E2.

Setting custom functions on the EOS 30D can create a camera that is fit just to your own shooting style, can give you more options in your photography, and are fun to experiment with. ⇨

Camera Operation Modes

Just like its 20D predecessor and its big brother, the 5D, the EOS 30D is a highly sophisticated and versatile digital camera. The innovation, thought, and technology that have been placed in this camera become evident as soon as you begin to operate its various systems and utilize its many functions. From finding focus on moving subjects to shooting multiple frames per second (fps) to capturing great exposures in low light, the 30D offers a number of options to help you take extraordinary photographs.

Focus

The 30D uses the 9-point AF system that was developed for the 20D. It features a special CMOS sensor dedicated to autofocus, though AF algorithms have been fine tuned for higher precision compared. The AF provides full cross-type performance (a high-level way for an AF sensor to work) with maximum apertures as small as f/5.6 (unusual for a camera in this class). The number of pixels on the central AF sensor was doubled compared to the 10D, which gave more consistent focus. The other eight sensors are placed near a golden section point (that mirrors classical art theories about composition), which results in more accurate autofocus with a whole range of compositions.

This CMOS AF-sensor is the foundation of an innovative system that is designed to minimize ghosting, which can limit focusing performance. Unwanted light is blocked by a narrow field-of-view and low-reflectance materials in the sensor area. In addition, the AF optics and housing have low expansion and low moisture absorption coefficients to keep autofocus consistent in all conditions.

◁ *The advanced technology and highly developed functions of the 30D give you the ability to capture great pictures every time you pick up your camera.*

The AF points work with an EV (exposure value) range of 0.5-18 (at ISO 100) and are superimposed in the viewfinder. They can be used automatically (the camera selects them as needed), or you can choose one manually. AF modes are selected by the photographer and include One-Shot AF, AI Servo AF, and AI Focus AF. Manual focusing is also an option.

The 30D smartly handles various functions of autofocus through the use of a high-performance, 32-bit microprocessor. The camera's ability to autofocus while tracking a moving subject is quite good. According to Canon for example, in AI Servo AF (continuous focus) with an EF 300mm f/2.8 USM lens, the 30D can focus-track a subject moving toward the camera at a speed of 186 mph up to about 66 feet (20 meters) away. It has the ability to very quickly employ statistical prediction while using multiple focusing operations to follow even an erratically moving subject. Yet, if the subject is not moving, the AI Servo AF focus control is notably stable—it will not allow the lens to change focus at all until the subject moves again.

When light levels are low, the camera activates AF assist with the built-in flash (external dedicated flashes also will do this). It produces a series of quick flashes to help autofocus. The range is to approximately 13 feet (4 meters) in the center of the frame and 11.5 feet (3.5 m) at the other AF points. The 580EX Speedlite includes a more powerful AF-assist beam effective to 33 feet (10.1 m).

AF Modes

The camera has three AF modes in addition to manual focus: One-Shot AF (AF stops and locks when focus is achieved, one-shot at a time), AI Servo AF (this tracks subject movement and focuses continuously until the exposure is made), and AI Focus AF (the camera switches automatically between One Shot and Servo as it detects movement of the subject). In the Basic Zone, the AF mode is set automatically. In the Creative Zone, you can choose among all three; they are accessed by pressing the AF•WB button located on top of the camera in front of the LCD Panel. Use

the Main Dial 📸 (on top of the camera behind the Shutter button) to scroll to the mode you want to use. Each is used for different purposes.

One-Shot AF: This AF mode finds and locks focus when you press the Shutter button halfway (exposure is also set). This is perfect for stationary subjects. It allows you to find focus and hold it at the important part of a subject. If the camera doesn't hit the right spot, it is a simple and quick matter to slightly change the framing and repress the Shutter button halfway to lock focus. Once you have found focus and locked, you can then move the camera to set the proper composition. The focus confirmation light will glow steadily in the viewfinder when you have locked focus. It will blink when the camera can't achieve focus. Since this camera focuses very quickly, a blinking light is a quick reminder that you need to change something (you may need to focus manually).

AI Focus AF: This mode allows the camera to choose between One-Shot and AI Servo. It can be used as the standard setting for the camera because it switches automatically from One-Shot to AI Servo if your subject should start to move. Note, however, that if the subject is still (like a landscape), this mode might detect other movement (such as a blowing tree), so it may not lock on the non-moving subject.

AI Servo AF: Great for action photography where subjects are in motion, AI Servo becomes active when you press the Shutter button down halfway, but it does not lock focus. It continually looks for the best focus as you move the camera or the subject travels through the frame. It is really designed for moving subjects, as both the focus and exposure are set only at the moment of exposure. This can be a problem to use for motionless subjects because the focus will continually change, especially if you are handholding the camera. However, if you are using AI Servo AF on a moving subject, it is a good idea to start the camera focusing (depressing the Shutter button halfway) before you actually need to take the shot so that the system can find the subject.

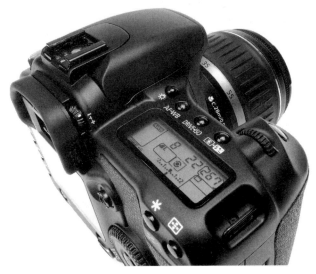

Select the AF mode of your choice by pressing the AF•WB button and using the Main Dial ⌒ to scroll to your desired mode.

Selecting an AF Point: You can have the camera select the AF point automatically, or you can use the Multi-controller ✣ to manually select a desired point. Manual AF point selection is useful when you have a specific composition in mind and the camera won't focus consistently where you want. To manually select an AF point, simply push the AF•WB button and move the ✣ in any direction to select a focus point. Points light up as they are selected. If you push the controller to an already lit point, the camera automatically selects them all. Pressing in the center of the ✣ will automatically select the center point. It is an intuitive control that is simple to use. You can also go back to auto AF point selection quickly by pressing the ✣ twice in any direction. In Custom Function-13, you can set the camera to allow you to select an AF point by only using the ✣ (this makes more sense to me). The AF button then takes you back

to full auto selection of AF points. It is possible to use the Main Dial 🔄 to move through all the AF points, but this is much slower because you have to circulate through each point, one at a time.

AF Limitations: AF sensitivity is high with this camera. Still, as the maximum aperture of lenses decreases, or tele-extenders are used, the camera's AF capabilities will change. It works its best with f/2.8 and wider lenses, and its function may be severely reduced at f/stops smaller than f/5.6. It is important to realize that this is normal and not a problem with the camera.

It is possible for AF to fail in certain situations, therefore requiring you to focus manually. This would be most common where the scene is low-contrast or has a continuous tone (such as sky), in conditions of extremely low light, with subjects that are strongly backlit or have glare behind them, and with compositions that contain repetitive patterns. A quick and easy way of dealing with these situations is to move the camera to focus on something at the same distance as the rest of the photo, lock focus on it, then move the framing back to the original composition.

Drive Modes and the Self-Timer

The 30D offers three shooting modes—Single shooting ☐ (one image at a time), High-speed continuous shooting 🔲H (5 frames per second), and Low-speed continuous shooting 🔲 (3 fps) shooting modes. The advantage of the Low-speed continuous mode 🔲 is that you can shoot continuously for a longer time period before the camera stops from a full buffer. There is also an option for a 10-second self-timer.

All drive modes are selected by pressing the DRIVE•ISO button then rotating the Main Dial 🔄. The chosen drive mode will appear in the LCD Panel as ☐ for Single shooting mode, and 🔲 or 🔲H for Continuous shooting mode, or as ⏱ for the Self-timer Operation.

The Self-timer ⟳ is set for ten seconds and can be used in any situation where you need a delay between the time you press the Shutter button and when the camera actually fires. It can even be helpful when you are shooting slow shutter speeds on a tripod and can't (or don't want to) use a cable release. The ten-second delay allows camera vibrations to settle down before the shutter goes off (in the case of using the self-timer and mirror lock-up, the self-timer will use a two-second delay).

Exposure

No matter what technology is used to create a photo, it is always preferable to have the best possible exposure. Digital photography is no exception. A properly exposed digital file is one in which the right amount of light has reached the camera's sensor and produces an image that corresponds to the scene, or to the photographer's interpretation of the scene. This applies to color reproduction, as well as tonal values and subject contrast.

ISO

Before the advent of DX barcodes for film canisters, the first step in getting the best exposure with film cameras was setting the ISO film speed. This provided the meter with information on the film's sensitivity to light, so that it could determine how much exposure would be required to record the image. Digital cameras adjust the sensitivity of the sensor circuits to settings that can be compared to film of the same ISO speed. (This change in sensitivity involves amplifying the electronic sensor data that creates the image.)

The 30D offers ISO sensitivity settings of 100-1600 but can also be set to "expand" to ISO 3200. This full ISO range is only available in the Creative Zone exposure modes (see page 115). In the Basic Zone modes (see page 113), ISO is set automatically from 100-400. The 30D offers more flexibility in how ISO equivalents are set compared to the 20D. ISO speed can now be set from ISO 100 to ISO 1600 in 1/3-stop incre-

ments. With the 20D, the ISO speed was only seen on the LCD panel. Now the 30D also displays ISO settings in the viewfinder when the DRIVE•ISO button is depressed so that you can set ISO without removing your eye from the finder.

ISO is one control worth knowing so well that its use becomes intuitive. Its speed can be quickly set in the Creative Zone. Since sensitivity to light is easily adjustable using a D-SLR, and since the 30D offers clean images with minimal to no noise at any standard setting, ISO is a control to use freely so you can adapt rapidly to changing light conditions.

Low ISO settings give the least amount of noise and the best color. Traditionally, film would increase in grain and decrease in sharpness with increased ISO. This is not entirely true with the 30D because its image is extremely clean. Some increase in noise (the digital equivalent of grain) will be noticed as the higher ISO settings are used, but it is minimal until the highest settings of 800 and 1600 are chosen. Little change in sharpness will be seen. Even the settings of 800 and 1600 offer very good results. This opens your digital photography to new possibilities for using slow lenses (lenses with smaller maximum lens openings, which are usually physically smaller as well) and in shooting with natural light.

Setting the ISO: To set the ISO speed, press the DRIVE•ISO button located on the top of the camera in front of the LCD Panel. Then turn the Quick Control Dial ⊙ until you see the desired displayed in the LCD Panel. The ISO settings occur in 1/3-stop increments. Most of the time you will want to choose among several key ISO settings: 100 to capture detail in images of nature, landscape, and architecture; 400 when more speed is needed, such as handholding for portraits when shooting with a long lens; and 800 and 1600 when you really need a lot of speed under low light conditions.

The camera also has a special ISO setting of 3200. Canon offers this as a specialized choice, available as Custom Function 08 (ISO expansion). The high speed of 3200 is distinctly noisier than lower settings, but if you are in a situa-

tion that requires such speed, the camera will give it to you. With ISO expansion selected to On, 3200 is added to the ISO choices. However, it does not appear as the number "3200." Instead, "H" appears in the LCD Panel.

Metering

In order to produce the proper exposure, the camera's metering system has to evaluate the light. However, even today there is no light meter that will produce a perfect exposure in every situation. Because different details of the subject reflect light in different amounts, the 30D's metering system has been designed with microprocessors and special sensors that give the system optimum flexibility and accuracy in determining exposure.

The 30D offers four user-selectable methods of measuring light: Evaluative (linked to any desired AF point), Partial, Center-Weighted, and new to the 30D, Spot metering. All four of these modes are set by pressing the Metering Mode Selection button ⧉ on top of the camera in front of the LCD Panel and then rotating the Main Dial ⧉. The symbol or icon for the type of metering in use appears on the LCD Panel.

⧉ **Evaluative Metering:** The 30D's Evaluative metering system divides the image area into 35 zones. As with all Canon EOS cameras, the 30D's Evaluative metering system is linked to autofocus. The camera actually notes which autofocus point is active and emphasizes the corresponding metering zones in its evaluation of the overall exposure. If the system detects a significant difference between the main point of focus and the different areas that surround this point, the camera automatically applies exposure compensation (it assumes the scene includes a backlit or spot-lit subject). However, if the area around the focus point is very bright or dark, the metering can be thrown off and the camera may underexpose or overexpose the image.

It is difficult to capture perfect exposures when shooting extremely dark or light subjects, subjects with unusual reflectance, or backlit subjects. Because the meter theoreti-

Experiment with the 30D's metering modes to improve your photographic skills and to create unique images.

cally bases its analysis of light on an average gray scene, when subjects or the scene differ greatly from average gray, the meter will tend to overexpose or underexpose them. Luckily, you can check exposure information on the LCD Panel, or check the image itself on the LCD Monitor, and make adjustments as needed.

Note: With Evaluative Metering, after autofocus has been achieved, exposure values are locked as long as the Shutter button is partially depressed. However, meter readings cannot be locked in this manner if the lens is set for manual focus. You must use the AE Lock button ✳ in that case.

The main advantage of Evaluative metering over Partial and Center-weighted metering is that the exposure is biased toward the active AF point, rather than just concentrating on the center of the picture. Plus, Evaluative metering is the

only metering mode that will automatically apply exposure compensation based on comparative analysis of the scene.

▣ *Partial Metering:* Partial metering covers about 9% of the frame, utilizing the exposure zones at the center of the viewfinder. This allows the photographer to selectively meter portions of a scene and compare the readings in order to select the right overall exposure. This can be an extremely accurate way of metering, but it does require some experience to do well. When shooting with a telephoto lens, Partial metering acts like spot metering.

⊡ *Spot Metering:* Canon has altered the optics of the metering system slightly for the 30D to enable Spot metering. This mode restricts the metering to a central 3.5% (approximate) of the viewfinder. This allows you to even more selectively meter a scene than Partial Metering, such as accurately metering a spot lit subject surrounded by totally different light. Like Partial Metering, Spot metering does require some practice to master.

☐ *Center-Weighted Metering:* This method averages the reading taken across the entire scene, but in computing the "average exposure," the camera puts extra emphasis on the reading taken from center of the horizontal frame. Since most early traditional SLR cameras used this method exclusively, some photographers have used Center-weighted metering for such a long time that it is second nature and they prefer sticking with it. It can be very useful with scenes that change quickly around the subject.

One thing you need to be aware of is how exposure is affected by the viewfinder eyepiece. This may sound odd, yet if you are shooting a long exposure on a tripod and do not have your eye to the eyepiece, there is a good possibility that your photo will be underexposed (it is over-influenced by light coming in from the eyepiece). To prevent this, Canon has included an Eyepiece cover on the camera strap that can be slipped over the viewfinder to block the opening in these conditions. You can quickly check the effect by

watching the LCD panel as you cover and uncover the eye-piece—you'll see how much the exposure can change.

Judging Exposure

The LCD Monitor allows you to get an idea of your photo's exposure—it's sort of like using a Polaroid, although it isn't as accurate. However, with a little practice, you can use this small image to evaluate your desired exposure, as long as you realize that it only gives an indication of what you will actually see when the images are downloaded into your computer (because of the Monitor's calibration, size, and resolution).

The EOS 30D includes two features that give you a good indication of whether or not each exposure is correct. These features, Highlight alert and the Histogram, can be seen on the LCD Monitor once an image is displayed there. Push the INFO button repeatedly to cycle through a series of three displays: one shows the image along with exposure information, another is a small photo showing Highlight alert along with the Histogram and exposure information, and the third shows the photo only (no info displayed).

Highlight Alert: The camera's Highlight alert is very straight-forward: overexposed highlight areas will blink on the small photo with the histogram display. These areas have so much exposure that only white is recorded, no detail. It is helpful to immediately see what highlights are getting blown out, but some photographers find the blinking is a distraction. Blinking highlights are simply information, and not necessarily bad. Some scenes have less important areas that will get washed out if the most important parts of the scene are exposed correctly. However, if you discover that significant parts of your subject are blinking, the image is likely overexposed. You need to reduce exposure in some way.

The Histogram: The 30D now gives the photographer a choice between the standard, Brightness (or luminance) histogram and a set of RGB histograms. The 30D's histogram is a very important tool for the digital photographer. It is the

graph that appears on the LCD Monitor next to the image when selected with INFO during review or playback, indicating the image's brightness. To select the brightness or RGB histograms, you must first choose one through the Playback menu's ▶ Histogram setting. For most photographers, the Brightness choice (Bright) is the best one. The RGB histograms (sRGB) are harder to interpret and really are of most use to commercial photographers who have very specific color balance needs.

The horizontal axis of the all histograms indicates the level of brightness—dark areas are at the left, bright areas are at the right. The vertical axis indicates the pixel quantity existing for the different levels of brightness. For RGB histograms, you are seeing levels of brightness for specific color channels (red, green, and blue). If the graph rises as a slope from the bottom left corner of the histogram, then descends towards and reaches the bottom before the right corner, all the tones of the scene are captured.

To read a histogram, consider the graph from left to right (dark to bright). If the graph itself starts too high on either end, i.e., so the "slope" looks like it is abruptly cut off at either side, then the exposure data is also cut off or "clipped" at the ends because the sensor is incapable of handling the areas darker or brighter than those points. An example would be a dark, shadowed subject on a bright, sunny day. In addition, the histogram may be weighted towards either the dark or bright side of the graph (wider, higher "hills" appear on one side or the other). This is okay if the subject is mostly dark or bright, but if it is not, detail may be lost. The dark sections of your photo may fade to black (with increased noise there), and brighter sections may appear completely washed out.

If highlights are important, be sure that the slope on the right reaches the bottom of the graph before it hits the right side. If darker areas are important, be sure the slope on the left reaches the bottom before it hits the left side. You don't actually have to remember which side is dark or

light at first. If you notice an unbalanced graph, just give the scene a change of exposure and notice which way the histogram changes. This is a really good way to learn to read the histogram.

Some scenes are naturally dark or light. In these cases, most of the graph can be on the left or right, respectively. However, be careful of dark scenes that have all the data in the left half of the histogram. Such underexposure tends to overemphasize any sensor noise that might be present. You are better off increasing the exposure, even if the LCD image looks bright enough. You can always darken the image in the computer, which will not affect grain; yet lightening a very dark image usually will have an adverse effect and result in added noise.

If the scene is low in contrast and the histogram is a rather narrow hill in the middle of the graph, check the 30D's Picture Style settings. Boosting contrast will expand the histogram— you can create a custom setting with contrast change and tonal curve adjustments that will consistently address such a situation. This can mean better information being captured since it is spread out more evenly across the tones before bringing the image into your computer to use image-editing software. In addition, this type of histogram is a good condition for using RAW, since the stretching of data to better use the tonal range from black to white looks best in RAW.

Basic Zone Shooting Modes
The 30D offers twelve exposure, or shooting, modes divided into two groups: the Basic and the Creative Zones. In the Basic Zone, the primary benefit is that the camera can be matched quickly to conditions or to a subject. Fast and easy to manage, the modes in the Basic Zone permit the camera to predetermine a number of settings. Exposure, ISO, and white balance are set automatically in all Basic Zone modes, while the metering method is Evaluative 🔲 . In some of these modes, all the controls are set by the camera and cannot be adjusted by the photographer.

All exposure modes, including the Basic Zone modes, are selected by using the Mode Dial ⊙ on the top left of the camera. Simply rotate the dial to the icon you wish to use.

☐ *Full Auto:* For completely automatic shooting, this mode essentially converts the 30D into a point-and-shoot camera (though a very sophisticated point-and-shoot!). The camera chooses everything—you cannot adjust any controls. This mode is really designed for the beginning photographer who does not trust his or her decisions, or for situations when you hand the camera to someone to take a picture of you (that way they can't mess up settings).

🦊 *Portrait:* If you like to shoot portraits, this makes adjustment choices that favor people photography. The drive is set to Continuous 🖳 so you can quickly shoot changing gestures and expressions, while the AF mode is set to One-Shot so you can lock focus with a slight pressing of the shutter release. The meter favors wider f/stops (those with smaller numbers) because this limits depth of field, offering backgrounds that are softer and therefore contrast with the sharper focus of the subject. A wider f/stop also results in faster shutter speeds, resulting in sharper handheld images, plus the camera chooses the Portrait Picture Style setting for better skin tones (most other Basic Zones use the Standard Picture Style).

🏔 *Landscape:* For a scenic, it is important to lock focus on one shot at a time, so Landscape mode uses One-Shot AF and the Single shooting drive mode ☐ . The meter favors small f/stops for more depth of field (often important for scenic shots), plus the camera chooses the more saturated and crisp Landscape Picture Style setting.

🌷 *Close-Up:* This zone also uses One-Shot AF and the Single shooting modes ☐ . It favors wider f/stops for faster shutter speeds giving better sharpness with a handheld camera, and for less depth of field in order to set a sharp subject off against a softer background and to employ .

Sports: Designed for action and fast shutter speeds to stop that action, Sports mode uses AI Servo AF and the Continuous drive mode ⏹ , both of which allow continuous shooting as action evolves in front of you. In addition, the beep for AF confirmation will be softer than other modes.

Night Portrait: Very useful to help even the advanced photographer balance flash with low light conditions (does not have to be night). This uses flash to illuminate the subject (which may or may not be a portrait), then uses an exposure to balance the background, bringing in its detail. The latter exposure, called the ambient light exposure, can have a very slow shutter speed, which may mean a blurry background (which can be very trendy looking or just unpleasant), so you may need a tripod.

Flash Off: Provides a quick and easy setting that prevents the flash from firing, which can be important in museums and other sensitive locations.

Creative Zone Modes

The Creative Zone modes offer complete control over camera adjustments and thus encourage a more creative approach to photography. The disadvantage is that there are many possible adjustments, which can be confusing at the worst, and time consuming at best. Again, all modes in the Creative Zone are engaged by turning the Mode Dial ⊙ to the desired designation. Adjustments to the settings, which are displayed in the LCD Panel and viewfinder, are made by turning the Main Dial ⌒ .

Program AE Mode (P): In Program AE (autoexposure), the camera chooses the shutter speed and aperture combination. This gives the photographer less direct control over the exposure because no matter how apt, the settings are chosen arbitrarily (by the camera, not you). However, you can "shift" the program by changing either the selected aperture or shutter speed, and the system will compensate to maintain the same exposure value. To shift the program, simply press the Shutter button halfway, then turn the Main

Dial 🖾 or Quick Control Dial ◌ until the desired shutter speed or aperture value (respectively) is displayed. This only works for one exposure at a time, making it useful for quick-and-easy shooting while retaining some control over camera settings.

Program AE mode selects shutter speed and aperture values "steplessly." This means that any shutter speed or aperture within the range of the camera and lens will be selected, not just those that are the standard full steps, such as 1/250 second or f/16. This has been common with most SLRs (both film and digital) for many years and allows for extremely precise exposure accuracy, thanks to the lens' electromagnetically controlled diaphragm and the camera's electronically timed shutter.

If the system determines there is risk of a bad exposure, the shutter speed and aperture values will blink in the viewfinder. When this occurs because there is too much light, a neutral-density (ND) or polarizing filter can be used to reduce the light coming into the lens. You can also decrease the ISO setting. If there is insufficient light, either increase the ISO speed or try using a larger aperture (smaller f/number).

Shutter-Priority AE Mode (Tv): Tv (which stands for "time value") signifies Shutter-Priority AE. Shutter-Priority means that you set the shutter speed and the camera sets the aperture. If you want a particular shutter speed for artistic reasons—perhaps a high speed to stop action or a slow speed for blur effect—use this setting. In this mode, even if the light varies, the shutter speed will not. The camera will keep up with changing light by adjusting the aperture automatically. If the aperture indicated in the viewfinder or the LCD Panel is consistently lit (not blinking), evaluative metering has picked a useable aperture. If the maximum aperture (lowest number) blinks, it means the photo will be underexposed and you need to select a slower shutter speed by turning the Main Dial 🖾 until the aperture indicator stops blinking. You can also remedy this by increasing the ISO

speed. If the minimum aperture (highest number) is blinking, this indicates overexposure. In this case, you should set a faster shutter speed until the blinking stops, or choose a slower ISO speed.

The 30D offers a choice of speeds, from 1/8000 second up to 30 seconds in 1/3-stop increments, plus Bulb setting. For flash exposures, the camera will sync at 1/250 second or slower (which is important to know since slower shutter speeds can be used to pick up ambient or existing light in a dimly-lit scene). Let's examine these shutter speeds by designating them "fast," "moderate," and "slow"—arbitrarily chosen so speeds at either end of the divisions can be designated into the groups on either side of them.

Fast shutter speeds are 1/500-1/8000 second. It wasn't all that long ago that most film cameras could only reach 1/1000 second, so having this range of high speeds on a D-SLR is quite remarkable. The obvious reason to choose these speeds is to stop action. The more the action increases in pace, or the closer it crosses directly in front of you, the higher the speed you will need. As mentioned previously, the neat thing about a digital camera is that you can check your results immediately on the LCD to see if the shutter speed has in fact frozen the action.

At these fast speeds, camera movement during exposure is rarely significant unless you try to handhold a super tele-photo lens of 600mm (not recommended!). This means with proper handholding technique, you can shoot using most normal focal lengths (from wide-angle to telephoto up to about 300mm) with few problems from camera movement. Besides stopping action, another important use of the high shutter speeds is to allow you to use your lens at its wide openings (such as f/2.8 or f/4) for selective focus effects (shallow depth of field). In bright sun, for example, you might have an exposure of 1/200 second at f/16 with an ISO setting of 200. You can get to f/2.8 by increasing your speed five whole steps of exposure, to approximately 1/4000 second.

Moderate shutter speeds (1/60-1/250 second) work for most subjects and allow a reasonable range of f/stops to be used. They are the real workhorse shutter speeds, as long as there's no fast action. You do have to be careful when hand-holding cameras at the lower end of this range, especially with telephoto lenses, or you may notice blur in your pictures due to movement of the camera during the exposure. Many photographers find that they cannot handhold a camera with moderate focal lengths (50-150mm) at shutter speeds less than 1/125 second without some degradation of the image due to camera movement. You can double-check your technique by taking a photograph of a scene while handholding the camera, and then comparing the same scene shot using a tripod.

Slow shutter speeds (1/60 second or slower) require something to stabilize the camera. Some photographers may discover they can handhold a camera and shoot relatively sharp images at the high end of this range, but most cannot get optimal sharpness from their lenses at these speeds without a tripod or other stabilizing mount. Slow shutter speeds are used mainly for low light conditions and to allow the use of smaller f/stops (higher f/stop numbers) under all conditions.

A fun use of very slow shutter speeds (1/8-1/2 second) is to photograph movement, such as a waterfall or runners, or to move the camera during exposure, such as panning it across a scene. The effects are quite unpredictable, but again, image review using the LCD Monitor helps. You can try different shutter speeds and see what they look like. This is helpful when trying to choose a slow speed appropriate for the subject because each speed will blur action differently.

The slow shutter speed used to take this picture gives the water a ▷
feeling of movement and action.

You can set slow shutter speeds (up to 30 seconds) for special purposes such as capturing fireworks or moonlit landscapes. Canon has engineered the sensor and its accompanying circuits to minimize noise (a common problem of long exposures with digital cameras) and the 30D offers remarkable results with these exposures.

In contrast to long film exposures, long digital exposures are not susceptible to reciprocity. The reciprocity effect comes with film because as exposures lengthen beyond approximately 1 second (depending on the film), the sensitivity of the film declines, resulting in the need to increase exposure to compensate. A metered 30-second film exposure might actually require double or triple that time to achieve the effect that is desired. Digital cameras do not have this problem. A metered exposure of thirty seconds is all that is actually needed.

The setting for Bulb Exposure allows you to control long exposures (*buLb* follows *30 seconds* when scrolling through shutter speeds). With this option, the shutter stays open as long as you keep the Shutter button depressed. Let go and the shutter closes. Two dedicated remote switches, the Canon RS-80N3 and TC-80N3, are very helpful for these long exposures, since they allow you to keep the shutter open without touching the camera (which can cause movement)—they attach to the camera with quick-lock plugs to the remote terminal on the left side. You can use the infrared LC-4 wireless remote switch for bulb exposures, as well.

The camera will show the elapsed time for your exposure as long as you keep the remote switch depressed. This can be quite helpful in knowing your exposure. The elapsed time is shown in seconds. At this point in digital camera technology, exposures beyond a few minutes start to have serious problems. Still, the 30D does allow longer exposures than most cameras of this type, and it is a good idea to use the Noise reduction Custom Function-02 Low. Exp noise reduction selection in the camera menu (see page 92)—this will apply added in-camera noise reduction.

Aperture-Priority AE Mode (Av): When you select Av (aperture value), you are in Aperture-Priority AE mode. In this autoexposure mode, you set the aperture (the f/stop or lens opening) and the camera selects the proper shutter speed for a proper exposure. This is probably the most popular automatic setting among professional photographers.

Controlling depth of field is one of the most common reasons for using Aperture-Priority mode. (Depth of field is the distance in front of and behind a specific plane of focus that is acceptably sharp.) While the f/stop, or aperture, affects the amount of light entering the camera, it also has a direct effect on depth of field. A small lens opening (higher f/number) such as f/11 or f/16 will increase the depth of field in the photograph, bringing objects in the distance into sharper focus (when the lens is focused appropriately). Higher f/numbers are great for landscape photography.

A wide lens opening with low f/numbers such as f/2.8 or f/4 will decrease the depth of field. These lower f/numbers work well for when you want to take a photo of a sharp subject that creates a contrast with a soft, out-of-focus background. If the shutter speed is blinking in the LCD Panel, it means good exposure is not possible at that aperture, so you either need to change the aperture or ISO setting.

You can see the effect of the aperture setting on the image by pushing the Depth-of-Field Preview button on the camera (located on the lower left of the front lens housing, below the Lens Release button). This stops the lens down to the taking aperture and reveals sharpness in the resulting darkened viewfinder (the lens otherwise remains wide-open until the next picture is taken). Using Depth-of-Field Preview takes some practice because of the viewfinder darkness. But changes in focus can be seen if you look hard enough. You can also just check focus in the LCD Monitor after the shot (magnify it as needed), since digital allows you to both review and/or delete your photos as you go.

A sports or wildlife photographer might choose Av mode in order to stop action rather than to capture depth of field. To accomplish this, he or she selects a wide lens opening—perhaps f/2.8 or f/4—to let in the maximum amount of light. In Av mode, the camera will then automatically select the fastest shutter speed possible for the conditions. With Tv mode, while you can set a fast shutter speed, the camera still may not be able to expose correctly if the light drops and the selected shutter speed requires an opening larger than the particular lens can provide (the aperture value will blink in the viewfinder in such a case). So typically photographers will select Tv only when they have to have a specific shutter speed. Otherwise they use Av for both depth of field and to gain the highest possible shutter speed for the circumstances.

Automatic Depth-of-Field AE (A-DEP): This is a unique exposure mode that Canon has used on a number of EOS SLR's (both film and digital) over the years. A-DEP simplifies the selection of an f/stop to ensure maximum depth of field for a subject. The camera actually checks focus, comparing all nine AF points to determine the closest and farthest points in the scene. The camera then picks an aperture to cover that distance and the appropriate shutter speed. You cannot control either yourself. It also sets the focus distance. If the camera cannot get an aperture to match the depth of field needed to cover the near and far points, the aperture will blink. You can check what the depth of field looks like by pushing in the Depth-of-Field Preview button. You have to use AF on the lens; MF will make the camera act like P was set. A-DEP also does not work with flash, and the camera will also act like P was set.

Manual Exposure Mode (M): Not an auto mode, the Manual Exposure option is important for photographers who are used to working in full manual (although I would suggest that everyone at least try the automatic settings at times to see what they can do; this camera is designed to give exceptional autoexposures), and also for anyone who faces certain tricky situations. In Manual Exposure, you set both the shutter speed (using the Main Dial 🕑) and aperture (set the

Power switch ON to the angled line, then turn the Quick Control Dial ◎). You can use the exposure metering systems of the camera—exposure is visible on the scale at the bottom of the Viewfinder information display. "Correct" exposure is at the mid-point, and you can see how much the exposure settings vary from that point by observing the scale. It shows up to two f/stops over or under the mid-point, which can allow you to quickly compensate for bright or dark subjects (especially when using Partial metering). If part of the scale blinks, the exposure is off the scale. Of course, you can also use a hand-held meter.

The following examples of complex metering conditions might require you to use M mode: panoramic shooting (you need a consistent exposure across the multiple shots taken, and the only way to ensure that is with Manual); lighting conditions that change rapidly around a subject with consistent light (a theatrical stage, for example); close-up photography where the subject is in one light but slight movement of the camera dramatically changes the light behind it; and any conditions where you need a consistent exposure through varied lighting conditions.

✱ AE Lock

AE Lock ✱ is a very useful tool in the autoexposure modes. Under normal operation, the camera continually updates exposure either as you move the camera across the scene or as the subject moves. This can be a problem if the light across the area is inconsistent yet remains constant on the subject. You will want to lock the exposure on the subject. This tool is also helpful when a scene is mostly in one light, yet your subject is in another. In that circumstance, try to find a spot nearby that has the same light as your subject, point the camera at it and lock exposure, then move the camera back to the original composition.

AE Lock ✱ on the 30D is similar to that used for most EOS cameras. Its button is signified by an asterisk and is located on the back of the camera to the upper right.

Aim the camera where you need proper exposure, then push this button. The exposure is "locked," or frozen, even if you move the camera. An asterisk will appear in the Viewfinder information display. The exposure scale on the right side gives important data—it compares the locked exposure in the center with the "present exposure" of the composition (the second dot). If you don't like what the lock gave for exposure, you can change it by pressing the ✱ again. You can also shift exposure by using the Main Dial ⌕ or apply a degree of compensation with the Quick Control Dial ◯ .

Exposure Compensation
The existence of a feature for exposure compensation, along with the ability to review images in the LCD Monitor, means you can quickly get good exposures without using Manual Exposure mode. Exposure compensation cannot be used in M mode. However, it makes the P, Tv, Av, and A-DEP modes much more versatile. Compensation is added (for brighter exposure) or subtracted (for darker exposure) in increments of 1/3 or 1/2 stops (you set this in Custom Function-06; see page 93) for up to +/- 2 stops.

It only works if the camera is active (i.e., you see both shutter speed and aperture in the Viewfinder information display) and works quite easily with the Quick Control Dial ◯ switched on (when the on switch is set to the angled line). Simply press the Shutter button halfway to turn on the metering system, then use your thumb to rotate the ◯ to change the compensation amount. You will see the exact exposure compensation on the scale at the bottom of the Viewfinder information display, as well as on the LCD Panel.

It is important to remember that once you set your Exposure Compensation control, it stays set even if you shut off the camera. Check your exposure setting as a regular habit (by looking at the bottom scale in the Viewfinder information display) when you turn on your camera to be sure the compensation is not inadvertently set for a scene that doesn't need it. With experience, you will find that you use

exposure compensation routinely with certain subjects. Remember, the meter wants to increase exposure on dark subjects and decrease exposure on light subjects to make them closer to middle gray. For this reason exposure compensation may be necessary.

For example, say you are photographing a high school baseball game with the sun behind the players. The camera wants to underexpose in reaction to the bright sunlight, but the shaded sides of the players' bodies may be too dark, so you add exposure with the 30D's Exposure Compensation feature. Or maybe the game is in front of densely shaded bleachers. In this case the players would be overexposed because the camera wants to react to the darkness. Here, you subtract exposure. In both cases, the camera will consistently maintain the exposure you have selected until you readjust the exposure settings.

The LCD Monitor can come in handy when experimenting with exposure compensation. Take a test shot, then check the photo and its histogram. If it looks good, go with it. If the scene is too bright, subtract exposure; if it's too dark, add it. Again, remember that if you want to return to making exposures without using compensation, you must move the setting back to zero!

Autoexposure Bracketing (AEB)
The 30D also offers another way to apply exposure compensation—by using the Autoexposure Bracketing control (AEB). AEB tells the camera to make three consecutive exposures that are different: (1) a standard exposure (it will use any setting of the Exposure Compensation function as the standard); (2) one with less exposure; and (3) one with more (this can be changed with Custom Function-09). The difference between exposures can be set up to +/- 2 stops in stop increments of 1/3 (Custom Function-06 will allow you to change this to 1/2 increments). AEB is set through the Shooting menu ◘ . Scroll to AEB with the Quick Control Dial ◯ , press SET ⑤ET , then use the ◯ again to set the amount. Three dots will appear on a small exposure scale on this

Sometimes a bright subject against a dark background can "fool" the camera's exposure meter. Using AEB can help to achieve a good exposure, even in more complex lighting situations.

menu (they will also appear on the LCD Panel). These indicate the range of exposures. Press (SET) to accept the change.

As you shoot, you will also see a marker appear on the exposure scale at the bottom of the Viewfinder information display. This marker indicates which exposure is being used with the AEB sequence. When in Single shooting mode ☐ , you have to press the Shutter button for each of the three shots. In Continuous shooting modes ⊒ , the camera will take the three shots and stop. With the Self-timer ꕀ , all three shots will be taken. While utilizing AEB, the 30D will change shutter speed in Tv mode and aperture in Av mode. If you use AEB, remember that the camera will continue to take three different exposures in a row until you reset the control to zero, turn the camera off, change lenses, or replace the CF card.

AEB can help ensure that you get the best possible image files for later adjustment using image-editing software. A dark original file always has the potential for increased noise as it is adjusted, and a light image may lose important detail in the highlights. AEB can help you to determine the best exposure for the situation. You won't use it all the time, but it can be very useful when the light in the scene varies in contrast or is complex in its dark and light values.

AEB is also important for a special digital editing technique that allows you to put multiple exposures together into one master to gain more tonal range from a scene. You can take the well-exposed highlights of one exposure and combine them with the better-detailed shadows of another (this works best with 1/2 stop bracketing). If you shot these different exposures with your camera on a tripod, they will line up exactly so that if you put the images on top of one another as layers using image-editing software, the different exposures are easy to combine. (You may even want to set the camera to continuous shooting—in this mode it will take the three photos for the AEB sequence and then stop.)

Flash

I have found that many photographers are slightly intimidated by flash. It used to be very hard to use, simply because you could not see its effects or how good your exposure was until you processed the film. Even the pros utilized Polaroid film tests because they could not totally predict what the flash would look like in the photo.

Digital photography has changed all that. With the LCD Monitor on your 30D, you can instantly see the effects of any use of flash. You can then adjust the light level, change the angle, soften the light, color it, and more. You can experiment with the 30D's built-in flash, or you may find you prefer an accessory flash.

With the purchase of your Canon EOS 30D, you gained more than a camera. You also gained access to an outstanding accessory flash system. The Canon EX Speedlite flash system includes a excellent range of flash units, from the basic to the extremely sophisticated.

You may know all about the use of electronic flash, but I know many good photographers new to the EOS D-SLR line don't know all that a flash can do for them. Electronic flash is not just a supplement for low light; it can also be a wonderful tool for creative photography. Flash is highly controllable, its color is precise, and the results are repeatable. However, the challenge is getting the right look, and many photographers shy away from using flash because they aren't happy with the results. This is because on-camera flash can be harsh and unflattering, and taking the flash off the camera used to be a complicated procedure with less than sure

Off-camera flash can give a more flattering and natural look to your pictures, especially portraits.

results. The EOS 30D's sophisticated flash system eliminates many of these concerns and, of course, the LCD Monitor gives instantaneous feedback. This alleviates the guesswork.

Here are some possibilities for using flash with your EOS 30D:

Fill Flash—Fill in harsh shadows in all sorts of conditions and use the LCD Monitor to see exactly how well the fill flash is working. You can even dial down the built-in or accessory flash to make its output more natural looking.

Off-Camera Flash—Putting a flash on a dedicated flash cord will allow you to move the flash to positions away from the camera and still have it work automatically. Using the LCD Monitor, you can see exactly what the effects are so you can move the flash up or down, left or right, for the best light and shadows on your subject. With Canon's EX Speedlites, you can also trigger certain units wirelessly, so you can have a flash off the camera and no cords attached.

Close-Up Flash—This used to be a real problem, except for those willing to spend some time experimenting. Now you can see exactly what the flash is doing to the subject. This works fantastically well with off-camera flash, as you can "feather" the light (aim it so it doesn't hit the subject directly) to gain control over its strength and how it lights the area around the subject. Canon's EX Speedlites include a special twin flash macro unit, though you can use most units for close-up work.

Multiple Flash—Modern flash systems have made exposure with multiple flash easier and more accurate. Plus, many manufacturers have created cordless systems. However, since the flash units are not on continuously, they can be hard to place so that they light the subject properly. Not anymore. With the 30D, it is easy to set up the flash, and then take a test shot. Does it look good or not? Make changes if you need to. In addition, this camera lets you use certain EX-series flash units (and independent brands with the same capabilities) that offer wireless exposure control.

Fill flash is a wonderful tool for giving dark areas of a scene a burst of light to bring them out and eliminate harsh shadows.

Digital photography is a great way to learn how to master multiple flash set ups.

Colored Light—Many flashes look better with a slight warming filter on them, but that is not what this tip is about. With multiple light sources, you can attach colored filters (also called gels) to the various flashes so that different colors light different parts of the photo (this can be a very trendy look).

Balancing Mixed Lighting—Architectural and corporate photographers have long used added light to fill in dark areas of a scene so the scene looks less harsh. Now you can double-check the light balance on your subject using the LCD Monitor. You can even be sure the added light is the right color by attaching filters to the flash to mimic or match lights (such as a green filter to match fluorescents or an amber filter to blend with incandescent lights).

Flash Synchronization

The 30D camera is equipped with an electromagnetically timed, vertically traveling focal-plane shutter. This shutter uses two curtains, one opens to expose the sensor to light, the second closes to shut off that light. For normal flash operation, the flash must go off when the sensor is fully exposed to light from the lens. One characteristic of focal-plane shutters, however, is that the entire surface of the sensor will not be exposed at the same time at shutter speeds faster than the flash sync speed. What happens is that the second curtain starts closing off the sensor before the first one has finished going across it. The shutter then forms a slit, which exposes the sensor as it moves across it. If you use flash with a shutter speed that is higher than the maximum flash sync speed, you get only a partially exposed picture. However, at shutter speeds below the maximum, the whole sensor surface will be exposed at some point to accept the flash; you can use any shutter speed you want that is 1/250 second or slower.

With the 30D, the maximum flash sync speed is 1/250 second (however, if you set the exposure to a speed faster than that in Tv or M modes when using flash, the camera will automatically reset the speed to 1/250). But the camera does offer high-speed sync with certain EX-series flash units that allow flash at all shutter speeds (even 1/8000 second where, basically, the flash fires continuously as the slit goes down the sensor). High-speed synchronization must be activated on the flash unit itself and is indicated by an H symbol on the flash unit's LCD Panel—see the flash manual for specific information on using high-speed flash sync. It does have some limitations, including how much power you get.

Guide Numbers

When shopping for a flash unit, compare guide numbers. A guide number (GN) is a simple way to state the power of the flash unit (it's computed as the product of aperture value and

subject distance) and is usually included in the manufacturer's specifications for the unit. High numbers indicate more power, however, it is important to understand that these numbers do not represent a linear relationship. Guide numbers act a little like f/stops (because they are directly related to f/stops!)—e.g., 56 is half the power of 80, or 110 is twice the power of 80. Since guide numbers are expressed in feet and/or meters, distance is part of the guide number formula. Guide numbers are usually based on an ISO 100 setting, but this can vary, so check the film speed reference (and determine whether the GN was calculated using feet or meters) when comparing guide numbers for different units. If the flash units you are comparing have zoom-head controls, make sure you compare the guide numbers for similar zoom-head settings.

Built-In Flash

The on-board flash built into the 30D's pentaprism housing at the top of the camera pops up higher than many older camera's built-in flash, thereby reducing the chance of get-

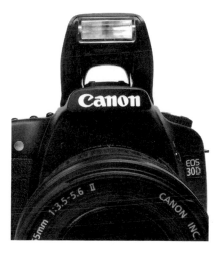

The built-in flash will pop up automatically in several of the Basic Zone exposure modes when the light is low.

133

The Flash button ⚡ *lets you raise the built-in flash at any time.*

ting red-eye and minimizing problems with large lenses blocking the flash. Similar to the 20D's flash, this unit supports Canon's sophisticated E-TTL II metering system for flash, covers a field of view up to a 17mm focal length and has a guide number of 43 (ISO 100, in feet). One thing that is different, however, is that it incorporates a new, highly durable Xenon tube to increase the life of the flash to match the 30D's increased shutter durability.

It is, like most built-in flash, not particularly high-powered, but its advantage is that it is always available and is very useful as fill-flash to modify ambient light. Unique to this flash and the 580EX, the flash sends color data to the camera's processor each time it fires. This helps the system measure many variables so that it can better maintain consistent color.

The flash pops up automatically in low light or backlit situations in the following Basic Zone exposure modes: Full Auto, Portrait, Close-Up, and Night Portrait. It will not acti-

vate in Landscape, Sports, or Flash Off modes. In the Creative Zone, you can choose to use the flash or not at any time. Just press the Flash button [012bm.tif]on the upper left of the lens mount housing, and the flash will pop up. To turn it off, simply push the flash down.

There are some variations in how the Creative Zone exposure modes work with the built-in flash. Program is fully automatic. Tv can be used when you need a specific shutter speed (as long as it is 1/250 second or slower). Av is very useful because it lets you very easily balance the light from the flash with the existing or ambient light of your scene—you set an aperture that the flash uses for its exposure and then the shutter speed influences how much of the "ambient" light (or natural light) will appear in the image. For M, you set the aperture for the flash then choose a shutter speed that is appropriate for your subject (1/250 second and slower).

Flash Metering

The 30D uses an evaluative auto exposure system, called E-TTL II, with improved flash control over earlier models (it is based on the E-TTL II system introduced in the pro-level EOS-1D Mark II and also used in the EOS-1D Mark IIN and EOS 5D). To understand the 30D's flash metering, you need to understand how a flash works with a digital camera on automatic. The camera will cause the flash to fire twice for the exposure. First, a preflash is fired to allow the camera to analyze exposure, and then the flash fires during the actual exposure, creating the image. During the preflash, the camera's evaluative metering system measures the light reflected back from the subject. Once it senses that the light is sufficient, it cuts off the flash and takes the actual exposure with the same flash duration. The amount of flash hitting the subject is based on how long the flash is "on," so close subjects will receive shorter flash bursts than more distant subjects. This double flash system works quite well, but you may also find that it causes some subjects to react by closing their eyes during the real exposure. However, they will be well exposed!

You can lock the flash exposure when either the pop-up flash or an attached flash is turned on by pressing the FE (Flash Exposure) Lock button ✱ (this is the same as the Exposure Lock button located on the upper right back of the camera). This causes the camera to emit a pre-flash so that it calculates the exposure before the shot. This also cancels the preflash that occurs immediately before the actual photograph (reducing the problem with people reacting to a pre-flash that occurs a split-second before the actual exposure).

To use this feature, turn the flash on, then lock focus on your subject by pressing the Shutter button halfway down. Next, aim the center of the viewfinder at the important part of the subject and press the ✱ (a ✱ with the flash icon ϟ will appear in the viewfinder). Now, reframe your composition and take the picture. FE Lock produces quite accurate flash exposures.

Using the same principle, you can make the flash weaker or stronger. Instead of pointing the viewfinder at the subject to set flash exposure, point it at something light in tone or a subject closer to the camera. That will cause the flash to give less exposure. For more light, aim the camera at something black or far away. With a little experimenting, and by reviewing the LCD Monitor, you can very quickly establish appropriate flash control for particular situations.

For the most control over flash, use the 30D's Manual exposure setting. Set an exposure that is correct overall for the scene then turn on the flash (flash exposure will still be E-TTL automatic.) The shutter speed (as long as it is 1/250 second or slower) controls the overall light from the scene (and the total exposure). The f/stop controls the exposure of the flash. So to a degree, you can make the overall scene lighter or darker by changing shutter speed, with no direct effect on the flash exposure (this does not work with high-speed flash).

Flash with Camera Exposure Modes

In the Basic Zones, you have no control over the flash. This means you have no say in when flash will be used for an exposure or how the exposure is controlled. The camera determines it all depending on how it senses the scene's light values. It will automatically be used when either the light is dim or there is a strong backlight.

In the Creative Zones, you either pop up the built-in flash by pushing the Flash button $\frac{1}{2}$ or attach an EX Speedlite accessory flash unit and simply switch it to the ON position. The flash will then operate in the various Creative Zone modes as detailed below:

Program AE (P)
Flash photography can be used for any photo where supplementary light is needed. All you have to do is turn on the flash unit—the camera does the rest automatically. Speedlite EX flash units should be switched to E-TTL and the ready light should be on, indicating that the flash is ready to fire. While shooting, you must pay attention to the flash symbol in the viewfinder to be sure that the flash is charged when you are ready to take your picture. The 30D sets flash synchronization shutter speeds of 1/60-1/250 second automatically in P mode and also selects the correct aperture. When the flash is turned on, any Program shift that has been set will be canceled.

Shutter-Priority AE (Tv)
This mode is a good choice in situations where you want to control the shutter speed when you are also using flash. In Tv mode, you set the shutter speed before or after a dedicated accessory flash is turned on. All shutter speeds between 1/250 second and 30 seconds will synchronize with the flash. With E-TTL Flash in Tv mode, synchronization with longer shutter speeds is a creative choice that allows you to control the ambient-light background exposure. A portrait of a person at dusk in front of a building with its lights on shot with conventional TTL flash would illuminate the person cor-

rectly but would cause the background to go dark. However, using Tv mode, you can control the exposure of the background by changing the shutter speed. (A tripod is recommended to keep the camera stable during long exposures).

Aperture-Priority AE (Av)

Using this mode lets you balance the flash with existing light, and it allows you to control depth of field in the composition. By selecting the aperture, you are also able to influence the range of the flash. The aperture can be selected by turning the Main Dial ⊙ and watching the flash's LCD Panel until the desired range appears. Then the camera calculates the lighting conditions and automatically sets the correct flash shutter speed for the ambient light.

Manual Exposure (M)

Going Manual gives you the most choices in modifying exposure. The photographer who prefers to adjust everything manually can determine the relationship of ambient light and electronic flash by setting both the aperture and shutter speed. Any aperture on the lens and all shutter speeds between 1/250 second and 30 seconds can be used. If a shutter speed above the normal flash sync speed is set, the 30D switches automatically to 1/250 second to prevent partial exposure of the sensor.

M mode also offers a number of creative possibilities for using flash in connection with long shutter speeds. The neat thing is that you don't have to calculate exposure manually because the flash sets exposure based on the f/stop you choose, plus you can check exposure in the LCD. You could use zooming effects with smeared background and a sharply rendered main subject, or take photographs of objects in motion with a sharp "flash core" and indistinct outlines.

Red-Eye Reduction

The 30D does offer a red-eye reduction feature for flash exposures. In low-light conditions when the flash is close to the axis of the lens (which it is with built-in flash), the flash will reflect back from the retina of peoples' eyes (because their pupils are wide). This appears as "red eyes" in the photo. You can reduce the chances of red-eye appearing by using an off-camera flash or by having the person look at a bright light before shooting.

The red-eye reduction feature of a camera is designed to cause the pupils of your subject to contract. On many cameras this is of questionable value because the flash fires a burst of light before the actual exposure. This often causes less than flattering expressions from your subject. The 30D, on the other hand, uses a continuous light from a bulb next to the handgrip, just below the Shutter button (you do have to be careful not to block it with your fingers), which helps the subject pose with better expressions. Red-eye reduction is set in the Shooting menu ◻ under *Red-eye On/Off*.

Canon Speedlite EX Flash Units

Canon offers a range of accessory flash units, called Speedlites, in the EOS system. While Canon Speedlites don't replace studio strobes, they are remarkably versatile. These highly portable flash units can be mounted in the camera's hot shoe or used off camera with a dedicated cord. The 30D is compatible with the EX-series of Speedlites. The EX-series flash units range in power from the Speedlite 580EX, which has a maximum GN of 190 (ISO 100, in feet), to the small and compact Speedlite 220EX, which has a GN of 72 (ISO 100, in feet). Speedlite EX-series flash units offer a wide range of features to expand your creativity. These are designed to work with the camera's microprocessor to take advantage of E-TTL exposure control, which extends the abilities of the 30D considerably.

I also strongly recommend Canon's Off-Camera Shoe Cord 2, an extension cord for your flash. With this cord, the flash can be moved away from the camera for more interesting light and shadow. You can aim light from the side or top of a close-up subject for variations in contrast and color. If you find that you get an overexposed subject, rather than dialing down the flash (which can be done on certain flash units), just aim the flash a little away from the subject so it doesn't get hit so directly by the light. That is often a quick fix for overexposure of close-ups.

Canon Speedlite 580EX

This top-of-the-line flash unit offers outstanding range and features adapted to digital cameras. It has many features in common with the 550EX but is slightly more powerful, has a faster recycling time, and is a more compact. The tilt/swivel zoom head on the 580EX covers focal lengths from 14mm to 105mm, and it swivels a full 180° in either direction. The zoom positions (which correspond to the focal lengths 24, 28, 35, 50, 70, 80, and 105mm) can be set manually or automatically (the flash reflector zooms with the lens). In addition, this flash "knows" what size sensor is used with a D-SLR and will vary its zoom accordingly. With the built-in retractable diffuser in place, the flash coverage is wide enough for a 14mm lens. It provides a high flash output with a GN of 190 (ISO 100, in feet) when the zoom head is positioned at 105mm. The guide number decreases as the angular coverage increases for shorter focal lengths, but is still quite high with a GN of 145 at 50mm, or GN 103 at 28mm.

The large, illuminated LCD Panel on the 580EX provides clear information on all settings: flash function, reflector position, working aperture, and flash range in feet or meters. The flash also includes a new Select Dial for easier selection of these settings. When you press the 30D's Depth-of-Field Preview button (on lower left of the lens mount housing), a one-second burst of light is emitted. This modeling flash allows you to judge the effect of the flash. The 580EX also has 13 user-defined custom settings that are totally inde-

pendent of the camera's custom functions; for more information, see the flash manual. When using multiple flashes, the 580EX can be used wirelessly either as a master flash or a slave unit.

Canon Speedlite 550EX

This model provides a GN of 182 (ISO 100, in feet) when the zoom head is positioned at 105mm. The guide number decreases as the angular coverage increases for wider angle lenses, but is still quite high with a GN of 139 at 50mm or GN 99 at 28mm. The tilt/swivel zoom head on the 550EX covers focal lengths from 24mm to 105mm. The zoom positions (which correspond to the focal lengths 24, 28, 35, 50, 70, 80, and 105mm) can be set manually or automatically (the flash reflector zooms with the lens). With the built-in retractable diffuser in place, the flash coverage is wide enough for a 17mm lens.

Just like the 580EX, the 550EX features a large, illuminated LCD Panel that provides clear information on all settings. It also works like the 580EX when you press the Depth-of-Field Preview button to judge the effect of your flash. This unit also has six custom settings that can be defined by the user. When using multiple flash units, the 550EX can be used wirelessly either as a master flash or a slave unit.

Canon Speedlite 420EX

The 420EX is less complicated, more compact, and less expensive than the top models. It offers E-TTL flash control, wireless E-TTL operation, and high-speed synchronization. The 420EX flash unit provides high performance with a GN of 138 (ISO 100, in feet) with the zoom reflector set for 105mm (somewhat weaker than the 550EX, but still quite powerful). The tilt/swivel zoom reflector covers focal lengths from 24 to 105mm. The zoom head operates automatically for focal lengths of 24, 28, 35, 50, 70, and 105mm. The setting for wireless E-TTL is made on the flash foot. When using multiple flashes, the 420EX can be used as a slave unit, but not as a master flash.

Other Speedlites

The Canon system also includes two specialized flash units for close-up photography that work well with the EOS 30D: the Macro Twin Lite MT-24EX and the Macro Ring Lite MR-14EX. They provide direct light on the subject.

Macro Twin Lite MT-24EX

The MT-24EX uses two small flashes affixed to a ring that attaches to the lens. These can be adjusted to different positions to alter the light and can be used at different strengths so one can be used as a main light and the other as a fill light. If both flash tubes are switched on, they produce a GN of 72 (ISO 100, in feet), and when used individually the guide number is 36. It does an exceptional job with directional lighting in macro shooting.

Macro Ring Lite MR-14EX

The MR-14EX has a GN of 46 (ISO 100, in feet) and both flash tubes can be independently adjusted in 13 steps from 1:8 to 8:1. It is a flash that encircles the lens and provides illumination on axis with it. This results in nearly shadowless photos (the shadow falls behind the subject compared to the lens position, though there will be shadow effects along curved edges). This flash is often used by photographers who want to show all the fine detail and color in a subject. It cannot be used for varied light and shadow effects. This flash is commonly used in medical and dental photography so that important details are not obscured by shadows.

Note: The power pack of both of these specialized flash units fits into the flash shoe of the camera. In addition, both macro flash units offer the same technical features as the 550EX, including E-TTL operation, wireless E-TTL flash, and high-speed synchronization among others. The MT-24EX models can also be used for wireless E-TTL flash.

Note: When the 30D is used with older system flash units (such as the EZ series), the flash unit must be set to manual, and TTL will not function. For this reason, Canon EX Speedlite system flash units are recommended primarily for use with the camera.

Bounce Flash

Direct flash can often be harsh and unflattering, causing heavy shadows behind the subject or underneath features such as eyebrows and bangs. Bouncing the flash softens the light and creates a more natural-looking light effect. The Canon Speedlite 580EX, 550EX, and 420EX accessory flash units feature heads that are designed to tilt so that a shoe-mounted flash can be aimed at the ceiling to produce soft, even lighting. The 580EX and 550EX also swivel (the 580EX 180° in both directions) so the light can be bounced off something to the side of the camera (a wall or reflector). However, the ceiling or wall must be white or neutral gray, or it may cause an undesirable color cast in the finished photo.

Wireless E-TTL Flash

With the wireless E-TTL feature, you can use up to three groups of Speedlite 580EXs, 550EXs, or 420EXs for more natural lighting or emphasis (the number of flash groups is limited to three, but the number of actual flash units is unlimited). The master unit and the camera control the exposure. A switch on the back of the foot of the 580EX and 550EX allows you to select whether the flash will be used as a master or a slave flash in the set up. The 420EX can only be used as a slave unit. Other wireless flash options include the Speedlite infrared transmitter (ST-E2), or the Macro Twin Lite MT-24EX.

To operate wireless TTL, a Speedlite 580EX or 550EX is mounted in the flash shoe on the camera. The switch on the unit's foot should be set so that it functions as a master unit, and slave units are set up in the surrounding area. The light ratio of slave units can be varied manually or automatically. With E-TTL (wireless) control several different Speedlite 420EXs, 550EXs, and 580EXs can be controlled at once.

Lenses and Accessories

The EOS 30D belongs to an extensive family of Canon EOS equipment, including lenses, flashes, and other accessories. With this wide range of available options, you could expand the capabilities of your camera quite easily should you want to. Canon has long had an excellent reputation for its lenses, and several independent manufacturers offer quality Canon compatible lenses as well.

The 30D can use both Canon EF and EF-S lenses, ranging from wide angle to tele-zoom, as well as single-focal-length lenses, from very wide to extreme telephoto. Keep in mind that magnification of both the widest angle and the farthest zoom are multiplied by the 30D's 1.6x magnification factor (see page 44). The EF 14mm f/2.8L lens, for example, is a super-wide lens with a 35mm camera, but offers the 35mm-format equivalent of a 22mm wide-angle lens when attached to the EOS 30D—wide, but not super-wide. On the other hand, put a 400mm lens on the camera and you get the equivalent of a 640mm telephoto—a big boost with no change in aperture (be sure to use a tripod for these focal lengths)!

Choosing Lenses

The focal length and design of a lens will have a huge affect on how you photograph. The correct lens will make photography a joy; the wrong one will make you leave the camera at home. One approach for choosing a lens is to determine if

Camera accessories can dramatically expand the already impressive capabilities available with the 30D.

you are frustrated with your current lenses. Do you constantly want to see more of the scene than the lens will allow? Then consider a wider-angle lens. Or maybe the subject is too small in your photos. Then look into acquiring a zoom or telephoto lens.

Certain subjects lend themselves to specific focal lengths. On small-format D-SLRs, like the 30D, wildlife and sports action are best photographed using focal lengths of 200mm or more. Portraits look great when shot with focal lengths between 50 and 80mm. Interiors often demand wide-angle lenses such as 10 or 16mm. Many people also like wide-angles for landscapes, but telephotos can come in handy for distant scenes. Close-ups can be shot with nearly any focal length, though skittish subjects such as butterflies might need a rather long lens.

These focal lengths have to be multiplied by 1.6 to be equivalent to traditional 35mm focal lengths. On most digital cameras, the digital sensors are smaller than a frame of 35mm film, so they crop the area seen by the lens, essentially creating a different format. Effectively, this magnifies the subject within the image area of the 30D and results in the lens acting as if it has been multiplied by a factor of 1.6 compared to 35mm film cameras.

Note: This is exactly the same thing that happens when one focal length is used with different sized film formats. For example, a 50mm lens is considered a mid-range focal length for 35mm, but it would be a wide-angle for medium format cameras.

This is great news for the photographer who needs greater magnification for wildlife or sports. A standard 300mm lens for 35mm film now acts like a 480mm lens on the 30D. You get an effectively long focal length in a smaller lens, often with a wider maximum f/stop, and with a much lower price. But this news is tough for people who need wide-angles, since the width of what the digital camera sees is significantly cropped in comparison to what a 35mm camera

146

would see using the same lens. You will need lenses with shorter focal lengths to see the same wide-angle field of view you may have been used to with film.

Zoom vs. Prime Lenses

When zoom lenses first came on the market, they were not even close to a single focal length lens in sharpness, color rendition, or contrast. Today, you can get superb image quality from either type. There are some important differences, though. The biggest is maximum f/stop.

Zoom lenses are rarely as fast (e.g. rarely have as big a maximum aperture) as single focal length, or prime, lenses. A 28-200mm zoom, for example, might have a maximum aperture at 200mm of f/5.6, yet a single focal length lens might be f/4 or even f/2.8. When zoom lenses come close to a single focal length lens in f/stops, they are usually considerably bigger and more expensive than the single focal length lens. Of course, they also offer a whole range of focal lengths, which a single focal length lens cannot do. There is no question that zoom lenses are versatile.

EF-Series Lenses

Canon EF lenses include some unique technologies. Canon pioneered the use of tiny autofocus motors in its lenses. In order to focus swiftly, the focusing elements within the lens need to move with quick precision. Canon developed the lens-based ultrasonic motor for this purpose. This technology makes the lens motor spin with ultrasonic oscillation energy instead of the conventional drive-train system (which tends to be noisy). This allows lenses to autofocus nearly instantly and with no noise (plus it uses less battery power than traditional systems). Canon lenses that utilize this motor are labeled USM (lower-priced Canon lenses have small motors in the lenses too, but they don't use USM technology, and can be slower and noisier).

Canon was also a pioneer in the use of image-stabilizing technologies. IS (Image Stabilizer) lenses use sophisticated motors and sensors to adapt to slight movement during exposure. It's pretty amazing—the lens actually has vibration-detecting gyro stabilizers that move a special image-stabilizing lens group in response to movement of the lens. This dampens movement that occurs from handholding a camera and allows much slower shutter speeds to be used. IS also allows big telephoto lenses (such as the EF 500mm IS lens) to be used on tripods that are lighter than would normally be used with non IS telephoto lenses.

The IS technology is part of many zoom lenses, and does a great job overall. However, IS lenses in the mid-focal length ranges have tended to be slower zooms matched against single focal length lenses. For example, compare the EF-S 17-85MM f4-5.6 IS USM lens to the EF 50mm f/1.8. The former has a great zoom range, but allows considerably less light at maximum aperture. At 50mm (a good focal length for people when using the 30D), the EF 17-85mm is an f/4 lens, more than two stops slower than the f/1.8 single focal length lens when both are shot "wide-open" (typical of low light situations). While you could make up that two stops in "handholdability" due to the IS technology, that also means you must use two full shutter speeds slower, which can be a real problem in stopping subject movement.

EF-S Series Lenses

EF lenses are the standard lenses for all Canon EOS cameras. EF-S lenses are small, compact lenses designed to only cover the format size of a small-format digital camera. They cannot be used with EOS film cameras, the EOS-1D series of D-SLRs or the EOS 5D, because the image area for each of those cameras is larger than that of the 30D's sensor.

With the introduction of the 30D, Canon also introduced a new EF-S lens. The EF-S 17–55mm f/2.8 IS USM offers superb image quality, on a par with L-series lenses, and with

the fast, constant f/2.8 aperture. This offers the equivalent of 27-88mm compared to 35mm. The constant aperture does result in a larger lens, however.

L-Series Lenses

Canon's L-series lenses use special optical technologies for high-quality lens correction. These include low-dispersion glass, fluorite elements, and aspherical designs. UD (ultra-low dispersion) glass is used in L-series telephoto lenses to minimize chromatic aberration, a common problem for telephoto lens designers. Chromatic aberration occurs when the lens can't focus all colors equally at the same point on the sensor (as well as on the film in a traditional camera). This results in less sharpness and a lot less contrast. Low-dispersion glass focuses colors more equally for sharper, crisper images.

Fluorite elements are even more effective (though more expensive) and have the corrective power of two UD lens elements. Aspherical designs are used with wide-angle and mid-focal length lenses to correct the challenges of spherical aberration in such focal lengths. Spherical aberration is a problem caused by lens elements with extreme curvature (usually found in wide-angle and wide-angle zoom lenses). Glass tends to focus light differently through different parts of such a lens, causing a slight, overall softening of the image even though the lens is focused sharply. Aspherical lenses use a special design that compensates for this optical defect.

With the introduction of the 30D, Canon also introduced a new EF lens. The EF 85mm f/1.2L II USM is a revision of the EF 85mm f/1.2L USM lens introduced in 1989. For the photographer who needs a telephoto with speed, this is an amazing lens. Its f/1.2 maximum aperture gives it light gathering ability that few other lenses can match, and offering an equivalent of 135mm on a full-size 35mm frame.

DO-Series Lenses

A relatively recent Canon optical design is the DO, which stands for diffractive optic. This is a very promising technology that significantly reduces the size and weight of a lens, and therefore is especially useful for big telephotos and zooms Yet, the lens quality is unchanged. The first two lenses produced by Canon in this series are a 400mm pro lens that is only two-thirds the size and weight of the equivalent standard lens, and a 70-300mm IS lens that offers a great focal length range while including image stabilization.

Macro and Tilt-Shift Lenses

Canon also makes some specialized lenses. Macro lenses are single-focal-length lenses optimized for high sharpness throughout their focus range, from very close (1:1 or 1:2) magnifications to infinity. These lenses range from 50mm to 180mm.

Tilt-shift lenses are unique lenses that shift up and down or tilt toward or away from the subject. They mimic the controls of a view camera. Shift lets the photographer keep the back of the camera parallel to the scene and move the lens to get a tall subject into the composition—this keeps vertical lines vertical and is extremely valuable for architectural photographers. Tilt changes the plane of focus so that sharpness can be changed without changing the f/stop. Focus can be extended from near to far by tilting the lens toward the subject, or sharpness can be limited by tilting the lens away from the subject (which has lately been a trendy advertising photography technique).

Independent Lens Brands

Independent lens manufacturers also make some excellent lenses that fit the 30D. I've seen quite a range in capabilities from these lenses. Some include low-dispersion glass and are stunningly sharp. Others may not match the best Canon

lenses, but offer features (such as focal length range or a great price) that make them worth considering. To a degree, you do get what you pay for. A low-priced Canon lens compared to a low-priced independent lens probably won't be much different. On the other hand, the high level of engineering and construction found on a Canon L-series lens can be difficult to match.

Filters and Close-Up Lenses

One myth that I have often heard today is that filters aren't needed for digital photography because adjustments for color and light can be made in the computer. That is absolutely wrong and such an attitude can really limit a photographer's capabilities and the quality of his or her work. Using filters can actually save a substantial amount of work in the digital darkroom by allowing you to capture the desired color and tonalities for your image right from the start. Even if you can do certain things in the computer, why take the time if you can do it more efficiently while shooting?

Of course, the LCD Monitor comes in handy once again. By using it, you can be sure you get the best from your filters. If you aren't sure how a filter works, you can simply try it and see the results immediately on the monitor. This is like using a Polaroid, only better, because you need no extra gear. Just take the shot, review it, and make adjustments to the exposure or white balance to help the filter do its job. If a picture doesn't come out the way you would like, you can discard and retake it right away.

Attaching filters to the camera depends entirely on your lenses. Usually, a properly sized filter can either be screwed directly onto a lens or fit into a holder that screws onto the front of the lens. There are adapters to make a given size filter fit several lenses, but the filter must cover the lens from edge to edge or it will cause dark corners in the photo (vignetting). A photographer may even hold a filter over the lens with his or her hand.

Here are a number of different types of very useful filters that perform different tasks for the digital photographer:

Polarizers

This important filter should be in every camera bag. Its effects cannot be exactly duplicated with software because it actually affects the way light is perceived by the sensor.

A polarizer darkens skies at 90° to the sun (this is a variable effect), reduces glare (which will often make colors look better), removes reflections, and increases saturation. While you can darken skies in the computer, the polarizer reduces the amount of work you have to perform in the digital darkroom. This filter will rotate in its mount, and as it rotates, the strength of the effect changes. While linear polarizers often have the strongest effect, they can cause problems with exposure, and often prevent the camera from autofocusing. Consequently, you are safer using a circular polarizer with the 30D.

Neutral Density Gray Filters

Called ND filters, this type is a helpful accessory. ND filters simply reduce the light coming through the lens. They come in different strengths, each reducing different quantities of light. Such filters give additional exposure options under bright conditions, such as a beach or snow (where a filter with a strength of 4x is often appropriate). If you like the effects when slow shutter speeds are used with moving subjects, a strong neutral density filter (such as 8x) usually works well. Of course, the great advantage of the digital camera, again, is that you can see the effects of slow shutter speeds immediately on the LCD Monitor so you can modify your exposure for the best possible effect.

Graduated Neutral Density Filters

Many photographers consider this filter an essential tool. It is half clear and half dark (gray) with a graduated blending through the middle. It is used to reduce bright areas (such as sky) in tone, while not affecting darker areas (such as the ground). The computer can mimic its effects, but you may not be able to recreate the scene you wanted. A digital camera's

sensor can only respond to a certain range of brightness at any given exposure, and if a part of the scene is too bright compared to the overall exposure, detail will be washed out and no amount of work in the computer will bring it back. The grad ND filter will allow you to bring that bright area down in tone so it is recorded with the proper density in the image.

UV and Skylight Filters
Though many amateur photographers buy these, pros rarely use them. The idea behind them is to give protection to the front of the lens, but they do very little visually. Still, they can be useful when photographing under such conditions as strong wind, rain, blowing sand, or going through brush.

If you do use a filter for lens protection, a high quality filter is best. A cheap filter can degrade the image quality of the lens. Remember that the manufacturer made the lens/sensor combination with very strict tolerances. A protective filter needs to be literally invisible, and only high-quality filters can guarantee that.

Close-Up Accessories
Close-up photography is a striking and unique way to capture a scene. Most of the photographs we see on a day-to-day basis are not close-ups, making those that do make their way to our eyes all the more noticeable. It is surprising to me that many photographers think the only way to shoot close-ups is with a macro lens. The following are four of the most common close-up options:

1. *Close-focusing zoom lenses with a macro or close-focus feature*
 Most zoom lenses allow you to focus up-close without accessories, although focal-length choices may become limited when using the close-focus feature. These lenses are an easy and effective way to start shooting close-ups. Keep in mind, however, that even though these may say they have a macro setting, it is really just a close-focus setting and not a true macro as described below in option four.

2. **Close-up accessory lenses**

 You can buy lenses that screw onto the front of your lens to allow it to focus even closer. The advantage is that you now have the whole range of zoom focal lengths available and there are no exposure corrections. Close-up filters can do this, but the image quality is not great. More expensive achromatic accessory lenses (highly-corrected, multi-element lenses) do a superb job with close-up work, but their quality is limited by the original lens.

3. **Extension tubes**

 Extension tubes fit in between the lens and the camera body of an SLR. This allows the lens to focus much closer than it could normally. Extension tubes are designed to work with all lenses for your camera (although older extension tubes won't work with EF-S lenses made specifically for Canon's small-format EOS cameras). Be aware that extension tubes do cause a loss of light.

4. **Macro lenses**

 Though relatively expensive, macro lenses are designed for superb sharpness at all distances and will focus from mere inches to infinity. In addition, they are typically very sharp at all f/stops.

Sharpness is a big issue with close-ups, and this is not simply a matter of buying a well-designed macro lens. The other close-up options can also give superbly sharp images. Sharpness problems usually result from three factors: limited depth of field, incorrect focus placement, and camera movement.

The closer you get to a subject, the shallower depth of field becomes. You can stop your lens down as far as it will go for more depth of field, or use a lens with a wider angle, but depth of field will still be limited. Because of this, it is critical to be sure focus is placed correctly on the subject. If the back of an insect is sharp but its eyes aren't, the photo will appear to have a focus problem. At these close distances, every detail counts. If only half of the flower petals are in focus, the overall photo will not look sharp. Autofo-

cus up close can be a real problem with critical focus placement because the camera will often focus on the wrong part of the photo.

Of course, you can review your photo on the LCD Monitor to be sure the focus is correct before leaving your subject. You can also try manual focus. One technique is to focus the lens at a reasonable distance, then move the camera toward and away from the subject as you watch it go in and out of focus. This can really help, but still, you may find that taking multiple photos is the best way to guarantee proper focus at these close distances. Another good technique is to shoot on the continuous drive mode and fire multiple photos. You will often find at least one shot with the critical part of your subject in focus. This is a great technique when you are handholding and when you want to capture moving subjects.

When you are focusing close, even slight movement can shift the camera dramatically in relationship to the subject. The way to help correct this is to use a high shutter speed or put the camera on a tripod. Two advantages to using a digital camera during close-up work are the ability to check the image to see if you are having camera movement problems, as well as the ability to change ISO settings from picture to picture to enable a faster shutter speed if you deem it necessary.

The Lens Release button located on the left side of the lens mount housing allows you to change lenses quickly and easily.

The best looking close-up images will often be ones that allow the subject to contrast with its background, making it stand out and adding some drama to the photo. There are three important contrast options to keep in mind. They apply to any photograph where you want the subject to stand out, but they can be easily applied to close-up subjects where a slight movement of the camera can totally change the background.

There are three important contrast options to keep in mind:

1. *Tonal or brightness contrasts*
 Look for a background that is darker or lighter than your close-up subject. This may mean a small adjustment in camera position. Backlight is excellent for this since it offers bright edges on your subject with lots of dark shadows behind it.

2. *Color contrasts*
 Color contrast is a great way to make your subject stand out from the background. Flowers are popular close-up subjects and, with their bright colors, they are perfect candidates for this type of contrast. Just look for a background that is either a completely different color (such as green grass behind red flowers) or a different saturation of color (such as a bright green bug against dark green grass).

3. *Sharpness contrast*
 One of the best close-up techniques is to work with the inherent limit in depth of field and deliberately set a sharp subject against an out-of-focus background or foreground. Look at the distance between your subject and its surroundings. How close are other objects to your subject? Move to a different angle so that distractions are not conflicting with the edges of your subject. Try different f/stops to change the look of an out-of-focus background or foreground.

Tripods and Camera Support

In order to get the most from a digital camera, you need to be aware that camera movement can affect sharpness and tonal brilliance in an image. Even slight movement during the exposure can cause the loss of fine details and the blurring of highlights. These effects are especially glaring when you compare an affected image to a photo that has no motion problems. In addition, affected images will not enlarge well.

You must minimize camera movement in order to maximize the capabilities of your lens and sensor. A steady hold on the camera is a start. Fast shutter speeds, as well as the use of flash, help to ensure sharp photos, although you can get away with slower shutter speeds when using wider-angle lenses. However, when shutter speeds go down, it is advisable to use a camera-stabilizing device. Tripods, beanbags, monopods, mini-tripods, shoulder stocks, clamps, and more all help. Many photographers carry a small beanbag or a clamp pod with their camera equipment for those situations where the camera needs support but a tripod isn't available. There is even a beanbag on the market with a tripod screw so it can be attached to your camera.

Check your local camera store for the variety of stabilizing equipment. A good tripod is an excellent investment. When buying a tripod, extend it all the way to see how easy it is to open, then lean on it to see how stiff it is. Both aluminum and carbon fiber tripods offer great rigidity. Carbon fiber is much lighter, but also more expensive.

The head is a very important part of the tripod and may be sold separately. There are two basic types for still photography: the ball head and the pan-and-tilt head. Both designs are capable of solid support and both have their passionate advocates. The biggest difference between them is how you loosen the controls and adjust the camera. Try both and see which seems to work better for you. Be sure to do this with a camera on the tripod because that added weight changes how the head works.

Working with the Computer

Camera to Computer

There are two main ways of copying digital files from the memory card into the computer. One way is to insert the card into an accessory known as a card reader. Card readers connect to your computer through the USB or FireWire ports and can remain plugged in and ready to download your pictures. The second way is to download images directly from the 30D using a USB interface cable (included with the camera at the time of purchase).

FireWire, if you have that capability on your computer, is generally faster than USB, which has two types: USB 1.0 and 2.0. Older computers and card readers will have the very much slower 1.0 version, but new devices are most likely 2.0 (which the 30D supports). This new version of USB can work as well as FireWire.

The advantage of downloading directly from the camera is that you don't need to buy a card reader, plus you can use Canon's new *Transfer Order* function (in the Playback menu ▶) to preset which photos you want to transfer from camera to computer. However, there are some distinct disadvantages in using the camera for transfer. For one, cameras generally download much more slowly than card readers (given the same connections). Plus, a camera has to be plugged into and unplugged from the computer for each use (the card reader can be left attached); you have to find a place for the camera where it won't be disturbed or in the way, too. As well as these drawbacks, downloading directly from a camera uses its battery power in making the transfer (or you need to plug it into AC power).

◁ *In the age of digital photography, the computer is an invaluable tool for sharing, organizing, and printing your images.*

The Card Reader

A card reader can be purchased at most photo and electronics stores. There are several different types, including single-card readers that read only one particular type of memory card, or multi-readers that are able to utilize several different kinds of cards. The latter is important with the 30D only if you have several cameras using different memory card types. If you just have EOS D-SLRs, you can use just a quality CompactFlash card reader (cheap, generic readers don't always work the way they should). After your card reader is connected to your computer, remove the memory card from your camera and put it into the appropriate slot in your card reader.

The card will usually show up as an additional drive on your computer (on Windows XP and Mac OS IX and X operating systems; for older versions you may have to install the drivers that come with the card reader). When the computer recognizes the card, it may also give instructions for downloading. You may want to follow these instructions if you are unsure about opening and moving the files yourself, but this is much slower than simply selecting your files and dragging them to where you want them.

Card readers can also be used with laptops, though PC card adapters may be more convenient as long as your laptop has a PC card slot. All you need is a PC card adapter for your particular type of memory card. Insert the memory card into the PC adapter, then insert the PC adapter into your laptop's PC card slot. The computer will recognize this as a new drive, and then you can drag and drop images from the card to the hard drive. The latest PC card adapter models tend to be faster but are also more expensive.

Working with Files

How do you edit and file your digital photos so that they are accessible and easy to use? To start, it helps to remember that your computer's hard drive is simply an electronic filing cabinet. Just as you could file photos in cabinet drawers and

folders, you can do the same thing virtually in the computer. It helps to create those "drawers" as overall or parent folders for things like years, then create folders specific to groups of images (i.e., XYZ Corporation, Portraits, Downtown Fair, Acme Equipment Demo, etc.).

Be sure to edit your photos and remove extraneous shots. Unwanted photos stored on your computer waste storage space on your hard drive, so you should store only the ones you intend to keep. Take a moment and review your pictures while the card is still in the camera. Erase the ones you don't want, and download the rest. You can also delete photos once downloaded to the computer by using a browser program (described below).

Here's how I deal with digital camera files. I use a memory card reader that shows up as a drive on my computer. Using the computer's file system, I open the memory card as a window or open folder (this is the same basic view on Windows and Mac computers) showing the images in the appropriate folder. I then open another window or folder on the computer's hard drive, and create a new subfolder labeled to signify the photographs on the memory card, such as Place, Topic, or Date. I also create all of these folders in a specific location on my hard drive—I use a parent folder (my "cabinet") called Digital Images. Then inside that, I use folders by year, then the individual shoots (you could use locations, months, whatever works for you). This is really no different than setting up an office filing cabinet with hanging folders or envelopes to hold photos.

I select all the images in the memory card folder and drag them to this new folder. This copies all the images onto the hard drive and into my "filing cabinet," which is actually better than using a physical filing cabinet because, for example, I can use browser software to rename all the photos in that new folder, giving information about each photo (such as HorsetailFallsColGrgOR 01).

I also set up a group of folders in a separate "filing cabinet" (a new folder at the level of Digital Images) for edited photos. In this second filing cabinet, I include sub folders specific to types of photography, such as landscapes, close-ups, people, etc. Inside them, I can break down categories even further when that helps to organize my photos. Inside these sub categories, I place copies of original images that I have examined and decided are definite keepers, both unprocessed (direct from the camera) and processed images (keeping such files separate). Make sure these are copies (rather than simply moving the files here), it is important to keep all "original" photo files in the original folder that they went to when first downloaded. (Another way of doing this is to use cataloging software such as ACDSee, iView Media Pro, or Extensis Portfolio; then you simply use keywords and other organizing tricks to create "virtual" folders or catalogs for your photos.)

Once you have downloaded your images onto the computer, back them up!!!! I can't emphasize this enough. I have two external hard drives just for this purpose. If all your images are on just the hard drive in your computer, you are asking for trouble. There are many external hard drive options. The key is to do it.

It also helps to burn important photos to a quality CD as soon as possible. Set up a CD binder for these protected photos. CDs are too small anymore for backing up large numbers of digital photos, so they are best used for important images. Be sure to use a quality, brand name CD-R (never CD-RW) for this back up. DVD is another alternative, although at this point, it is still not 100% readable if you need to go from computer to computer.

Browser and Cataloging Programs

While the latest Photoshop has an improved browser that can help organize photos, it still doesn't do as well as software specifically made for this purpose. There are currently a number of programs that help view and organize your images.

A browser is helpful for seeing your photographic results quickly and navigating through them more easily.

ACDSee is a superb program with a customizable interface, keyboard tagging of images, and some unique characteristics such as a calendar feature that lets you find photos by date (though the best featured version is Windows only). In addition, you can tag images with key words or categories so you can instantly do a search and find a group of photos. Another very good program with similar capabilities is iView Media Pro (with equal features on both Windows and Mac versions) as well as Extensis Portfolio (Windows and Mac). You may also want to check out Digital PhotoPro, which was designed by professional photographers and has some interesting pro features, including a magnifying digital "loupe."

All of these browser programs include some database functions (such as keyword searches) and the ability to create virtual catalogs. These programs allow you to quickly

look at photos on your computer, edit them, rename photos one at a time or all at once, read all major files, move photos from folder to folder, resize photos for e-mailing, create simple slideshows, and more.

An important function of browser programs is their ability to print customized index prints. You can then give a title to each of these index prints, and also list additional information about the photographer as well as the photo's file location. The index print is a hardcopy that allows easy reference (and visual searches). A combination of uniquely labeled file folders on your hard drive, a browser program, and index prints will help you to maintain a fast and easy way of finding and sorting images.

Image Processing

Of course, you can process the 30D's JPEG files in any image-processing program. One nice thing about JPEG is that it is one of the most universally recognizable formats. Any program on any computer that opens image files will recognize JPEG. That said, it is important to understand that the original JPEG file is more like a negative than a slide. Sure, you can use it directly, just like you could have the local mini-lab make prints from negatives. But JPEG files can be processed to get more out of them.

While RAW files offer more capacity for change, you can still do a lot with a JPEG file to optimize it for use. I used to shoot mainly JPEG for my professional work because it fit my workflow and personality, and no clients complain about the quality of my images. Now I usually shoot both JPEG and RAW for the benefits of both.

RAW, as discussed earlier, is an important format because it increases the options for adjustment of your images. When shooting RAW, you have to work on every image, which does change your workflow. This is why photographers often use the 30D's ability to record RAW and JPEG at the same time.

The big advantage to the RAW file is that it captures more directly what the sensor sees. It holds more information (12-bits vs. the standard 8-bits per color) and can have stronger correction applied to it (compared to JPEG images) without problems showing. This can be particularly helpful when there are difficulties with exposure or color balance. (Remember that the image file from the camera holds 12-bits of data even though it is contained in a 16-bit file—so while you can get a 16-bit TIFF file from the RAW file, it is based on 12 bits of data.)

Note: 30D RAW files are nearly 9 MB in size, so they will fill memory cards quite quickly. In addition, they can increase processing and workflow times.

Canon offers two ways of converting CR2 files to standard files that can be optimized in Photoshop: the EOS Utility Ver.1.0 and the Digital Photo Professional software. In addition, Photoshop's Camera Raw RAW converter, Phase One's Capture One (C-1) software and Pixmantic RawShooter have some high-level features for RAW conversion and workflow that many photographers like. There is a slight quality difference between using these and using the Canon software, which after all was created specifically for Canon's proprietary RAW file. However, the difference is small.

The EOS Utility
This software from Canon is easy to use. It is a good "browser" program that lets you view and organize RAW and JPEG files. It will convert RAW files, though it is a pretty simple program and doesn't offer some of the features available in other RAW processing software. Even so, it does a very good job of translating details from the RAW file into TIFF or JPEG form. Once converted, the new TIFF or JPEG files are readable by any image-processing program. TIFF is the preferred file format (JPEG would only be used if you had file space limitations). The EOS Utility supplied with the 30D is much faster than earlier utilities that came with EOS cameras. In addition, it includes EOS Capture, a remote capturing control that lets you work your camera remotely when attached to the computer.

Digital Photo Professional Software

Digital Photo Professional (DPP) was developed to bring Canon RAW file processing up to speed with the rest of the digital world. This program now comes with the 30D and will work on all presently available EOS cameras. It can be used to process both CR2 files and JPEG files. The advantage to processing JPEG files is that DPP is quicker and easier to use than Photoshop, yet is still quite powerful. So for fast and simple JPEG processing, DPP works quite well. DPP is fast, full-featured and gives excellent results.

Storing Your Images

Even though digital images are stored as digital files, they can still be lost or destroyed without proper care. Many photographers use two hard drives, either adding a second one to the inside of the computer or using an external USB or FireWire drive. This allows you to immediately and easily back-up photos on the second drive. It is very rare for two drives to fail at once.

Hard drives and memory cards are all devices known as magnetic media. As such, they do a great job at recording image files for processing, transmitting, sharing, and more. However, they are not good for long-term storage. Magnetic media have a limited life. Most manufacturers won't rate such storage devices beyond 10 years. This is a conservative number, to be sure, but this type of media has been known to lose data in that time span.

There are also a number of malicious computer viruses that can wipe out image files from a hard drive (especially JPEGs). Even the best drives can crash, rendering them unusable. Plus, we are all capable of accidentally erasing or saving over an important photo.

One answer to these storage problems is to use more than one accessory hard drive, so that at least one can be separated from your computer at times for protection. Another

answer is optical media. A CD-writer (or "burner") is a necessity for the digital photographer. DVD-writers work extremely well, too, and DVDs can handle about six times the data that can be saved on a CD. Either option allows you to back up photo files and store images safely.

There are two types of disk media used for recording data, but only one should be used for photo storage: R designated (i.e. CD-R or DVD-R) recordable disks; and RW designated (i.e. CD-RW or DVD-RW) rewritable disks. CD-R disks can only be recorded once—they cannot be erased and no new images can be added to them. This makes them far more stable. CD-RWs, on the other hand, can be recorded on and then erased and reused later, and you can add more data to them as well. For long-term storage of your images, use CD-R disks, period.

Buy quality media. Inexpensive disks can fail within years. Read the box. Look for information about the life of the disk. Most long-lived disks are labeled as such and cost a little more.

Direct Printing

With certain compatible Canon printers, you can control the printing directly from the 30D. Simply connect the camera to the printer using the dedicated USB cord that came with the printer. With the 30D, Canon also introduced new printers, the Pixma Pro9500 and Pro9000 desktop photo printers that support direct printing features unique to the 30D/Pixma combination. These features include full support for Picture Style settings, fine adjustment of image quality settings such as color balance, color space (including Adobe RGB), overall brightness, and a red-eye correction function, and expanded paper selection, including a range of fine art paper stocks available in a variety of sizes up to 13x19-inches.

In addition, the camera is PictBridge compatible (meaning that it can be directly connected to any PictBridge printer from other manufacturers). Most new photo printers are Pict-Bridge compatible. With these printers, you use the USB cord that came with the camera.

Note: RAW files cannot be used for the direct printing options mentioned in this section.

To start the process, first set the camera to communicate with the printer. Do this in the Set-up menu **↑↑** under *Communications*—then select *PTP*. Next, making sure that both the camera and the printer are turned off, connect the camera to the printer with the camera's USB cord (the connections are straightforward since the plugs only work one way). Turn on the printer first, then the camera; this lets the camera recognize the printer so it is prepared to control it (some printers may turn on automatically when the power cable is connected). Depending on the printer, the actual direct printing features of the camera will vary.

Press the Playback button ▶ and use the Quick Control Dial 🌀 to select an image on the LCD Monitor that you want to print. There will be an icon in the upper left to indicate the printer is connected. Press the SET button ⒮ⓔⓣ and the *Print Setting* screen will appear, giving such printing choices as whether to imprint the date, to include effects, number of copies, trimming area, and paper settings (size, type, borders or borderless). Continue to use the 🌀 and ⒮ⓔⓣ to set these options to the desired settings. These choices may change depending on the printer; refer to the printer's manual if necessary.

Trimming is a neat choice because it allows you to actually crop your photo right in the LCD Monitor before printing, so you can tighten up the composition if needed.

Note: The amount of control you have over the image when printing directly from the camera is limited entirely by the printer, and often you will have little or no control over color and brightness. If you really need image control, print from the computer.

If you are shooting a lot of images for which you plan to use direct printing, do some test shots and set up the 30D's Picture Styles to optimize the prints before actually shooting the final pictures. You may even want to create a custom setting that increases sharpness and saturation just for this purpose.

Digital Print Order Format (DPOF)

Another printing feature of the 30D is DPOF (Digital Print Order Format). This allows you to decide which images to print before you actually do any printing. Then, if you have a printer that recognizes DPOF, it will print those specifically chosen images automatically. It is also a way to select images on a memory card for printing at a photo lab. When you drop off your CF card with images selected using DPOF—assuming the lab's equipment recognizes DPOF (ask before you leave your card)—the lab will know which prints you want.

DPOF is accessible through the Playback menu ▶ under Print Order. You can set the options you want, choosing all or any combination of individual images. Select *Set Up* to choose Print Type (standard or index), Date (on or off), and File No. (on or off). After setting up your choices, press the MENU tab on the display to return to *Print Order*. From there, select to choose either *Order* or *All* and release. Order allows you to use the Quick Control Dial 🔄 to select which individual images you want to print, along with their quantity (All selects all the images on the card for printing). RAW files cannot be selected for DPOF printing.

Quick Glossary

aberration
An optical flaw in a lens that causes the image to be distorted or unclear.

angle of view
The area seen by a lens, usually measured in degrees across the diagonal of the film frame.

anti-aliasing
A technique that reduces or eliminates the jagged appearance of lines or edges in an image.

artifact
Information that is not part of the scene but appears in the image due to technology. Artifacts can occur in film or digital images and include grain, flare, static marks, color flaws, noise, etc.

barrel distortion
A defect in the lens that makes straight lines curve outward away from the middle of the image _ most noticeable toward the edges of the frame.

buffer
Temporarily stores data so that other programs or operations, on the camera or the computer, can continue to run while data is in transition.

built-in meter
A light-measuring device that is incorporated into the camera body.

bulb
A camera setting that allows the shutter to stay open as long as the shutter release is depressed.

chromatic aberration
Occurs when light rays of different colors are focused on different planes, causing colored fringing or halos around objects in the image.

chrominance
A component of an image that expresses the color (hue and saturation) information, as opposed to the luminance (lightness) values.

CMYK mode
Cyan, magenta, yellow, and black. This mode is typically used in image-editing applications when preparing an image for commercial printing.

compression
A method of reducing file size through removal of redundant data, as with the JPEG file format.

contrast filter

A colored filter that lightens or darkens the monotone representation of a colored area or object in a black-and-white photograph.

critical focus

The most sharply focused plane within an image.

diaphragm

A mechanism that determines the size of the lens opening that allows light to pass into the camera when taking a photo.

diopter

A measurement of the refractive power of a lens element -- this is typically used to identify the amount of correction at the eyepiece to allow the photographer to better see the viewfinder. Also, it may be a supplementary lens that is defined by its focal length and power of magnification.

DPOF

Digital Print Order Format. A feature that enables the camera to supply data about the printing of image files and supplementary information contained within them – usually used by photo labs. The lab's printer must be DPOF compatible for the system to operate.

electronic rangefinder

A system that utilizes the AF technology built into a camera to provide a visual confirmation that focus has been achieved. It can operate in either manual or AF focus modes.

FP high-speed sync

Focal Plane high-speed sync. This allows flash units to be synchronized at shutter speeds higher than the standard sync speed. In this flash mode, the level of flash output is reduced and, consequently, the shooting range is reduced.

full-frame

The maximum area of the sensitized medium (film or sensor) that can capture the image from the lens. Also used to refer to full-frame sensor

guide number

A number used to quantify the output of a flash unit. It is derived by using this formula: GN = aperture x distance. Guide numbers are expressed for a given ISO film speed in either feet or meters.

interpolation
Process used to increase image resolution by creating new pixels based on existing pixels. The software intelligently looks at existing pixels and creates new pixels to fill the gaps and achieve a higher resolution.

lithium-ion
A popular battery technology (sometimes abbreviated to Li-ion) that is not prone to the charge memory effects of nickel-cadmium (Ni-Cd) batteries or the low temperature performance problems of alkaline batteries.

luminance noise
A form of noise that appears as a sprinkling of black and white_grain_ in an image.

Moiré
A moiré pattern occurs because the _frequency_ of detail in a scene conflicts with the resolution on a sensor. Moiré appears as a wavy pattern over the image.

pan
Moving the camera to follow a moving subject. When a slow shutter speed is used, this creates an image in which the subject appears sharp and the background is blurred.

polarization
An effect achieved by using a polarizing filter. It minimizes reflections from non-metallic surfaces like water and glass and saturates colors by removing glare. Polarization often makes skies appear bluer at 90 degrees to the sun. The term also applies to the above effects simulated by a polarizing software filter.

RGB mode
Red, Green, and Blue. This is the color model most commonly used to display color images on video systems and computer monitors. It displays all visible colors as combinations of red, green, and blue. RGB mode is the most common color mode for viewing and working with digital files onscreen.

slow sync
A flash mode in which a slow shutter speed is used with the flash in order to allow ambient light to be recorded by the sensor along with the flash.

synchronize
When the flash exposes the sensor (or film) correctly because the flash unit fires simultaneously with the complete opening of the camera's shutter.

USB

Universal Serial Bus. This inter-
face standard allows outlying
accessories to be plugged and
unplugged from the computer
while it is turned on. USB 2.0
enables high-speed data transfer.

vignetting

A reduction in light at the edges
or corners of an image, darken-
ing them. This can be caused by
lens aberrations, too large a fil-
ter or an inappropriate lens
hood. This can also occur by
using a small-format lens on a
larger-format digital camera.

Wi-Fi

A technology that allows for
wireless networking between
one Wi-Fi compatible product
and another; stands for Wireless
Fidelity.

Index

Photoshop (see Adobe
 Photoshop)
Picture Styles 56-61
playback (see image review)
Portrait mode 60, **114**, 134
printing 21, 55, 57, 59, 74, **167**-
 169
processing parameters **56**
Program AE mode **115**-116
program shift **137**

Q

quality 20, 44, 45, 68, **73**-77,
 80, 86, 91, 95, 147, 148, 153,
 154, 167

R

RAW 20, 21, 22, 32, 48, **53**-55,
 56, 59, 61, 62, 68, **70**-77, 80,
 91, 113, 164, 165, 166, 168,
 169
red-eye 29, 36, 40, 80, 134,
 139, 167
remote switch 47, **120**
resolution **21**-22, 32, 38, 46,
 56, 73, 74, 80, 83, 111

S

self-timer 29, 40, 47, **105**-106,
 126
sensor 12, 15, 19, 20, 21, 27,
 28, 32, 35, 39, 40, **44**-47, 54,
 55, 70, 71, 76, 82, 83, 97,
 101, 106, 108, 112, 113, 120,
 132, 138, 140, 146, 148, 149,
 152, 153, 157, 165
Shutter-Priority AE mode **116**
Speedlite flash units (see flash)
Sports mode **115**

T

TIFF **165**
tripod 47, 106, 110, 115, 118,
 127, 138, 145, 148, 155, **157**
TV playback **90**

U

USB 32, **159**, 166, 167, 168

V

viewfinder 24, **35**-38, 40, 47,
 56, 81, 83, 88, 94, 102, 103,
 107, 110, 115, 116, 121, 122,
 123, 124, 126, 136, 137
vignetting **151**

W

white balance 24, 29, 33, 36,
 37, 40, 41, 54, **61**-70, 73, 76,
 80, 86, 94, 113, 151